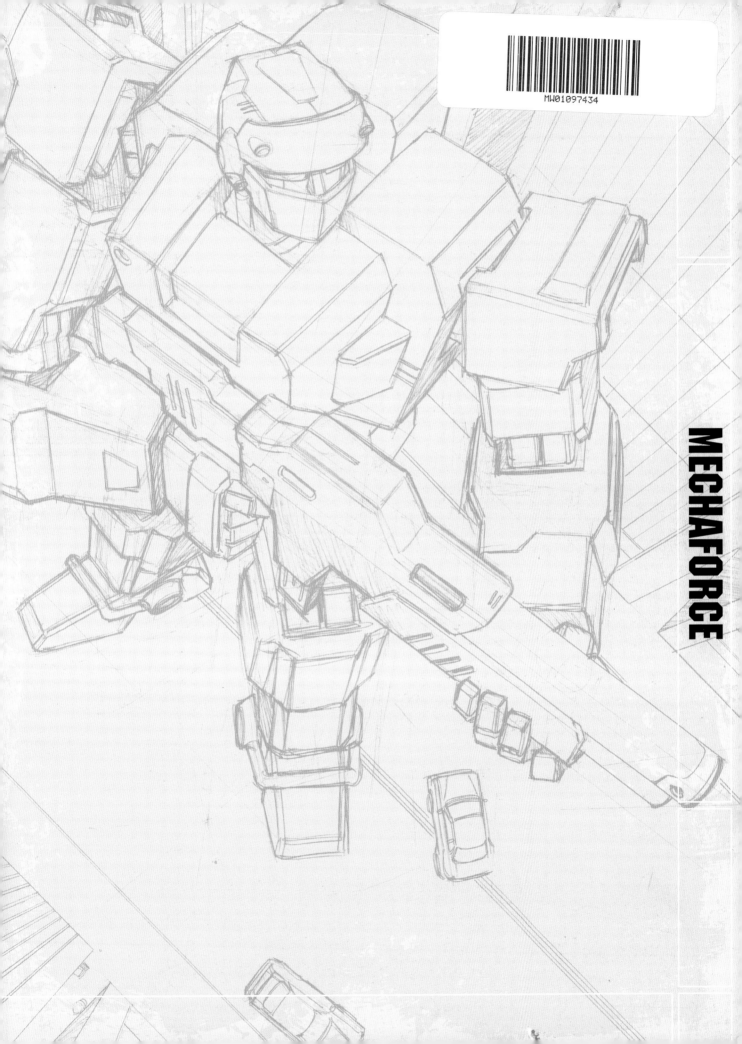

MECHAFORCE

MECHAFORCE

Draw Futuristic Robots that Fly, Fight, Battle and Brawl

E.J. SU

IMPACT
CINCINNATI, OHIO
www.impact-books.com

ABOUT THE AUTHOR

E.J. Su was born in Taiwan and moved to the United States at age 14. In college, he first wanted to learn to program video games and declared his major in computer science.

E.J. grew up reading only Japanese comics. Some of his favorite comics and animations include *Microman*, *Astro Boy*, *Black Jack*, *Ghost in the Shell*, *Doraemon* and *Dragon Ball*. He didn't start reading American comics until the mid-1980s when he came across Alan Moore's *The Killing Joke*.

E.J. has been heavily influenced by Japanese comic book artists. Some of the most influential include Masamune Shirow, Akira Toriyama, Osamu Tezuka, Fujiko F. Fujio and Mitsuru Adachi. In recent years, E.J. has started to draw inspiration from Travis Charest, Adam Hughes, Leinil Francis Yu and Bruce Timm.

fw
F+W PUBLICATIONS, INC.

Published by IMPACT Books, an imprint of F+W Publications, Inc., 4700 East Galbraith Road, Cincinnati, Ohio, 45236. (800) 289-0963. First Edition.

Other fine IMPACT Books are available from your local bookstore, art supply store or visit our website at www.fwpublications.com.

12 11 10 09 08 5 4 3 2 1

DISTRIBUTED IN CANADA BY FRASER DIRECT
100 Armstrong Avenue
Georgetown, ON, Canada L7G 5S4
Tel: (905) 877-4411

DISTRIBUTED IN THE U.K. AND EUROPE BY DAVID & CHARLES
Brunel House, Newton Abbot, Devon, TQ12 4PU, England
Tel: (+44) 1626 323200, Fax: (+44) 1626 323319
Email: postmaster@davidandcharles.co.uk

DISTRIBUTED IN AUSTRALIA BY CAPRICORN LINK
P.O. Box 704, S. Windsor NSW, 2756 Australia
Tel: (02) 4577-3555

Library of Congress Cataloging in Publication Data
Su, E. J.
 Mechaforce : draw futuristic robots that fly, fight, battle and brawl / E.J. Su.
 p. cm.
 Includes index.
 ISBN-13: 978-1-60061-014-1 (pbk. : alk. paper)
 ISBN-10: 1-60061-014-5 (pbk. : alk. paper)
 1. Robots in art. 2. Drawing--Technique. I. Title.
 NC825.R56S82 2008
 743'.89629892--dc22 2007039153

Edited by Jeffrey Blocksidge
Designed by Terri Woesner and Wendy Dunning
Production coordinated by Matt Wagner

METRIC CONVERSION CHART

To convert	to	multiply by
Inches	Centimeters	2.54
Centimeters	Inches	0.4
Feet	Centimeters	30.5
Centimeters	Feet	0.03
Yards	Meters	0.9
Meters	Yards	1.1

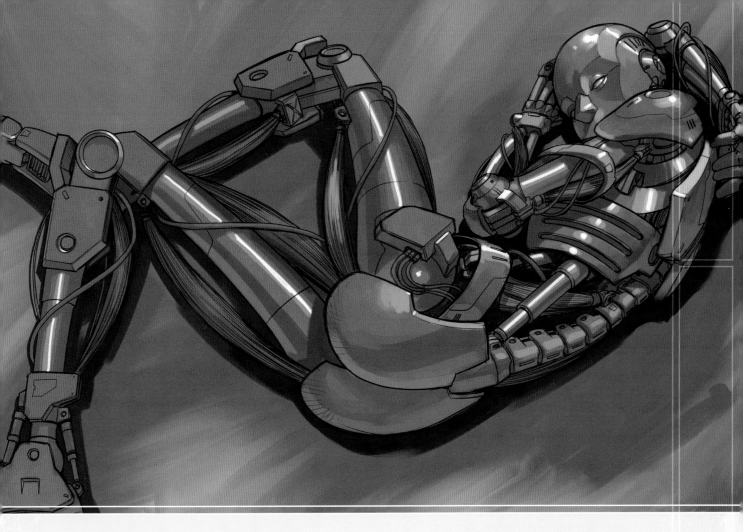

ACKNOWLEDGMENTS

I'd like to thank all the people who helped me through the bad times, and those who helped me along the way to what will hopefully be a long career in comic book illustration, including the Inkpunks crew, whom I worked with on our short-lived anthology that was the kick start of my comic book career, and Robert Kirkman, who gave me my first big break on the Image book *Tech Jacket*.

Val Staples, who believed in my work and helped me with all the insider knowledge of the comic book world.

Chris Ryall and Dan Taylor, who gave me an opportunity on *Transformers* and for being patient with me.

Thanks also to all those fans who supported me and picked up the books I have created. I wouldn't be here without any of you.

And last but not least, thanks to Jeffrey Blocksidge and the rest of the team at IMPACT Books, for putting up with my long, drawn-out schedule.

DEDICATION

This book is dedicated to my wife, Michelle. Thank you for your patience and understanding. I am so blessed having you by my side. Having you with me is the biggest accomplishment in my life.

INTRODUCTION 7

1 SHAPE, PERSPECTIVE AND TECHNIQUE 8

2 ROBOTIC ANATOMY 32

3 DRAWING ROBOTS 52

TABLE OF CONTENTS

INTRODUCTION

My goal for this book is to show what beginning artists need to know about designing a robot from scratch. I believe in starting with the fundamentals. Showing you how to draw a robot isn't enough. Knowing the mechanics of a working robot is important to your success. Once you learn how things work, you can expand this knowledge on your own and design your own robot.

Mechanical-looking ideas and designs are just the tip of the iceberg of your own imagination. Study this material carefully and practice often. By the time you finish this book, you should be able to design a robot with solid mechanics beneath its metal skin.

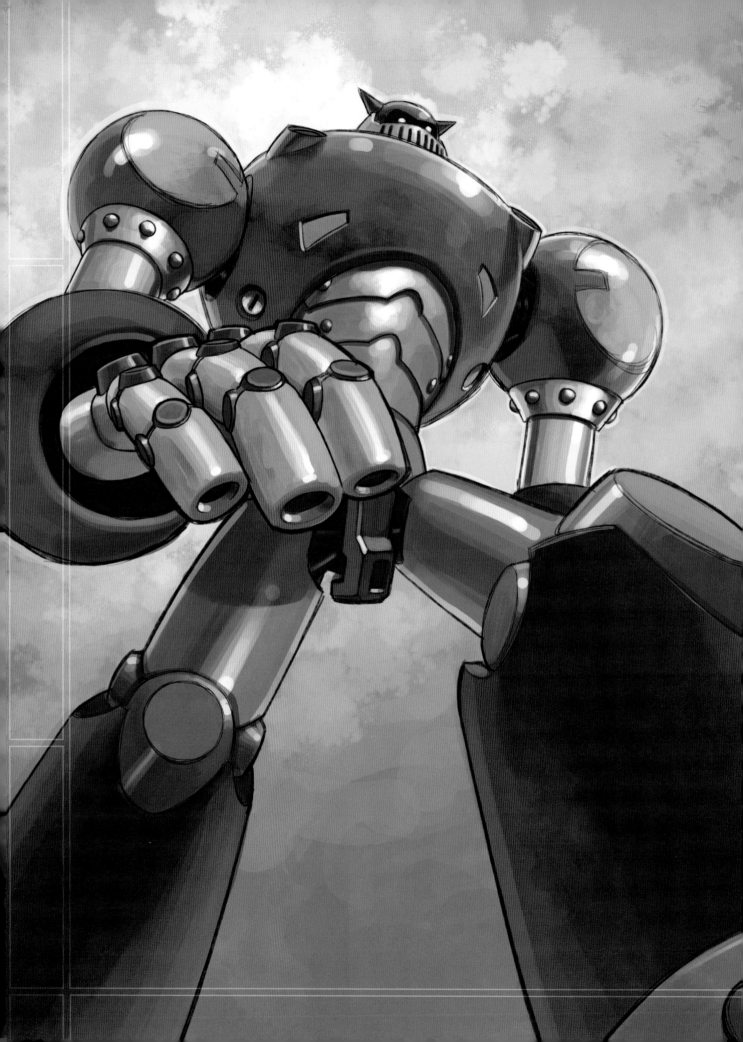

1 SHAPE, PERSPECTIVE AND TECHNIQUE

Building a set of fundamental skills has always been the best way to go about learning to draw. The world is made of combinations of basic shapes, and perspective represents the way we see this world on paper. A good grasp of basic forms and perspective will help you convey what you see or imagine. If you're a beginner wanting to jump right in and start drawing robots, you might find these basics boring and tedious. I know how you feel. But I was fortunate enough to be introduced to these fundamentals early in my life, and from them my artistic skills grew. These fundamentals will go a long way in helping your skills grow as well. Since basic form and perspective are subjects all by themselves, this chapter will only be an overview, providing you with a glance at how forms behave in different perspectives.

BASIC SHAPES

Understanding basic shapes will help you visualize how a robot is constructed. Because robots are mechanical, manufactured things, their bodies are made up of geometric forms.

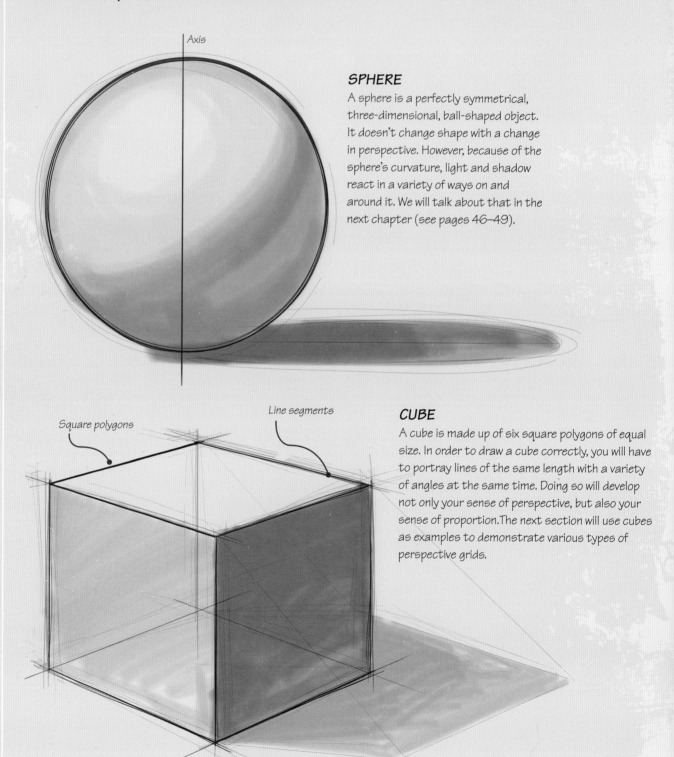

Axis

SPHERE

A sphere is a perfectly symmetrical, three-dimensional, ball-shaped object. It doesn't change shape with a change in perspective. However, because of the sphere's curvature, light and shadow react in a variety of ways on and around it. We will talk about that in the next chapter (see pages 46–49).

Square polygons

Line segments

CUBE

A cube is made up of six square polygons of equal size. In order to draw a cube correctly, you will have to portray lines of the same length with a variety of angles at the same time. Doing so will develop not only your sense of perspective, but also your sense of proportion. The next section will use cubes as examples to demonstrate various types of perspective grids.

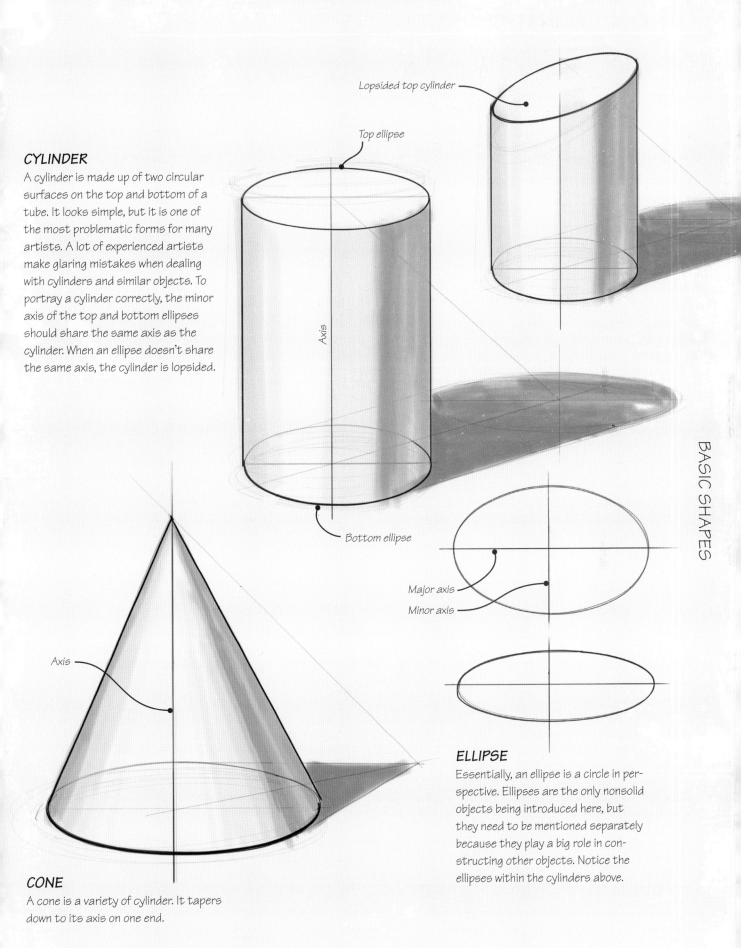

CYLINDER

A cylinder is made up of two circular surfaces on the top and bottom of a tube. It looks simple, but it is one of the most problematic forms for many artists. A lot of experienced artists make glaring mistakes when dealing with cylinders and similar objects. To portray a cylinder correctly, the minor axis of the top and bottom ellipses should share the same axis as the cylinder. When an ellipse doesn't share the same axis, the cylinder is lopsided.

Lopsided top cylinder

Top ellipse

Axis

Bottom ellipse

Major axis

Minor axis

Axis

CONE

A cone is a variety of cylinder. It tapers down to its axis on one end.

ELLIPSE

Essentially, an ellipse is a circle in perspective. Ellipses are the only nonsolid objects being introduced here, but they need to be mentioned separately because they play a big role in constructing other objects. Notice the ellipses within the cylinders above.

ONE-POINT PERSPECTIVE

One-point perspective is the basic form of perspective. A simple one-point perspective with one vanishing point is used most often. One-point perspective works best in scenes dealing with eye-level angles.

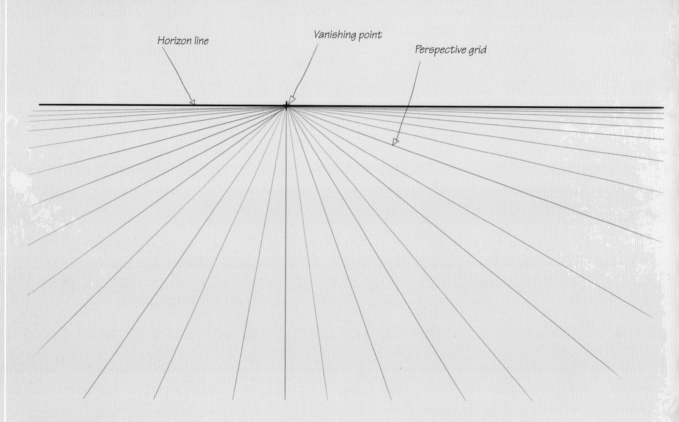

Horizon line

Vanishing point

Perspective grid

PICK A POINT

To set up one-point perspective, choose a point on the horizon line to be your vanishing point. Pick the point carefully; it should be one that would show the form of your object best. All the lines on the perspective grid should converge at this one vanishing point.

ONE-POINT PERSPECTIVE IN A SCENE →

All horizontal lines on the structures recede to the vanishing point at the rear of the scene. A vanishing point is the artist's way of expressing distance.

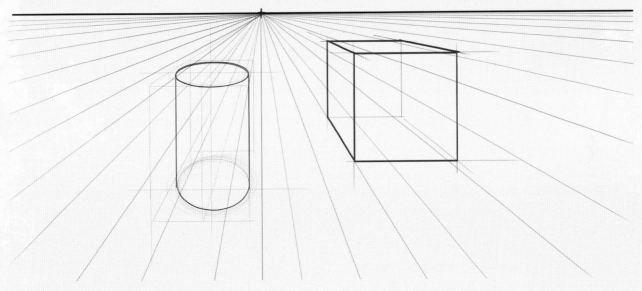

ALL PARALLEL LINES CONVERGE

Here is a cube and a cylinder in one-point perspective. Notice the parallel lines on the cube. If extended, they would all converge at the vanishing point. Make sure the minor axes of the ellipses overlaps the axis of the cylinder. This should always be the case when drawing a cylinder.

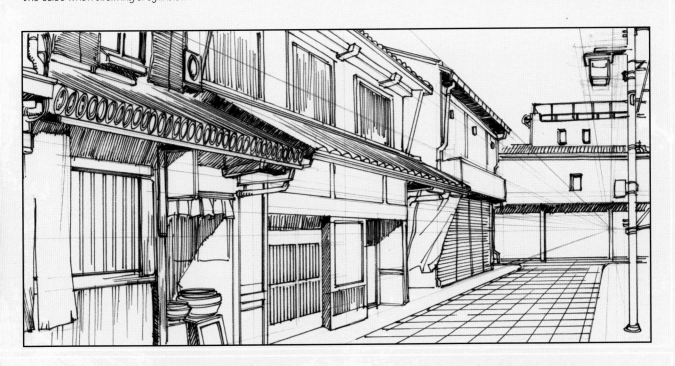

TWO-POINT PERSPECTIVE

Two-point perspective is used for wider views that show more space. If a scene is capturing a radical angle from a wide view, it would become nearly impossible to use only one vanishing point without making objects in the scene look distorted.

PICK TWO POINTS

In addition to the first vanishing point, establish a second vanishing point on the horizon line.

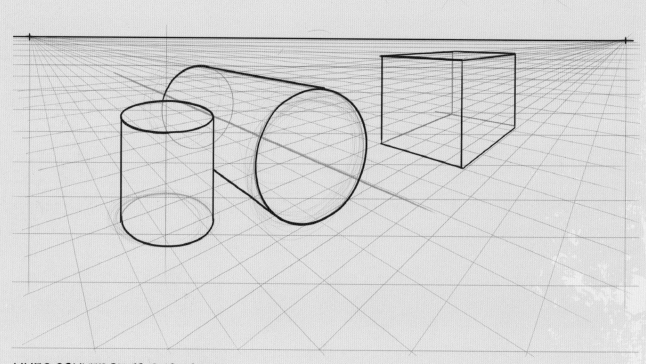

LINES CONVERGE TO TWO POINTS

Here are a variety of basic forms in two-point perspective. Notice the horizontal cylinder's lines only converge at one point. The cube has lines that converge at both points.

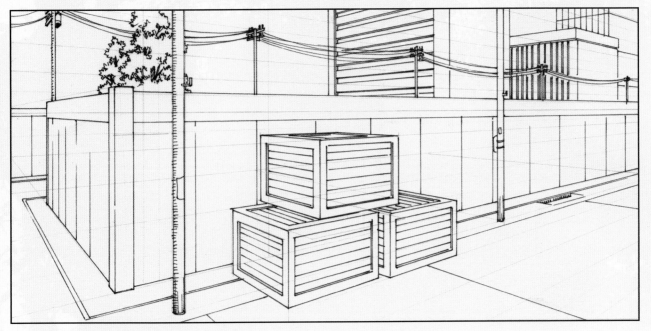

TWO-POINT PERSPECTIVE IN A SCENE

The two vanishing points give a sense of distance in two places: around the corner to the left, and farther down the way to the right.

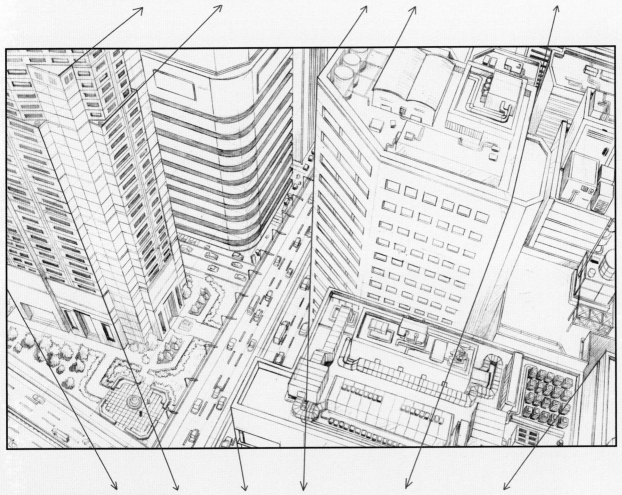

EXPERIMENT WITH POINTS

This is another effective way of using two-point perspective. Two-point perspective can effectively create a dynamic scene. Here, one point is below the ground; the roof lines all point to a separate point off the paper.

THREE-POINT PERSPECTIVE

Adding a third vanishing point to a scene can be confusing at times, but it is the most accurate way to represent the real world in perspective.

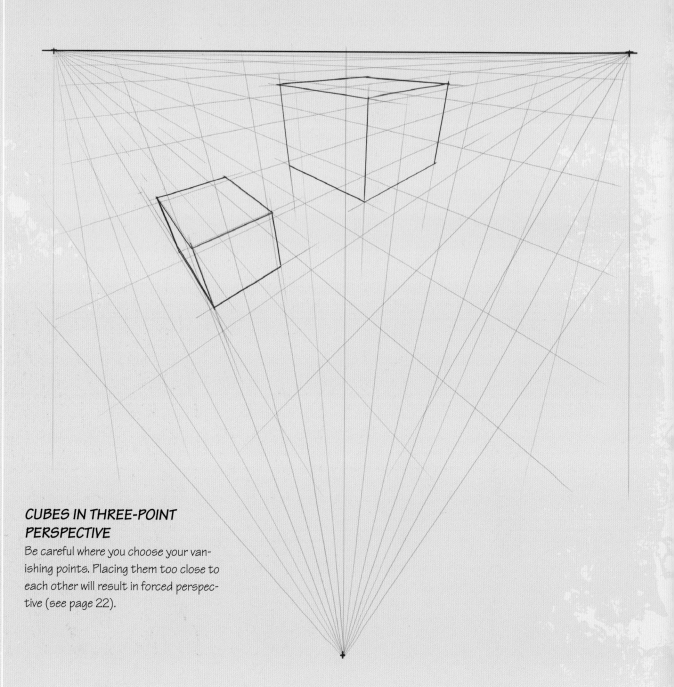

CUBES IN THREE-POINT PERSPECTIVE

Be careful where you choose your vanishing points. Placing them too close to each other will result in forced perspective (see page 22).

16

THREE-POINT PERSPECTIVE IN A SCENE

Distance is expressed in the height, length and width of this scene. Three vanishing points in a three-dimensional world is the most realistic perspective.

ROBOTS IN PERSPECTIVE

You can break down most things into their basic forms, especially robots. Going from basic forms to a full-size robot can be rather intimidating for beginning artists. But robots are essentially made of boxes that are stacked and connected to one another. Thinking this way will allow you to start concentrating on the overall form of the robot. Deal with the body parts individually to keep confusion to a minimum.

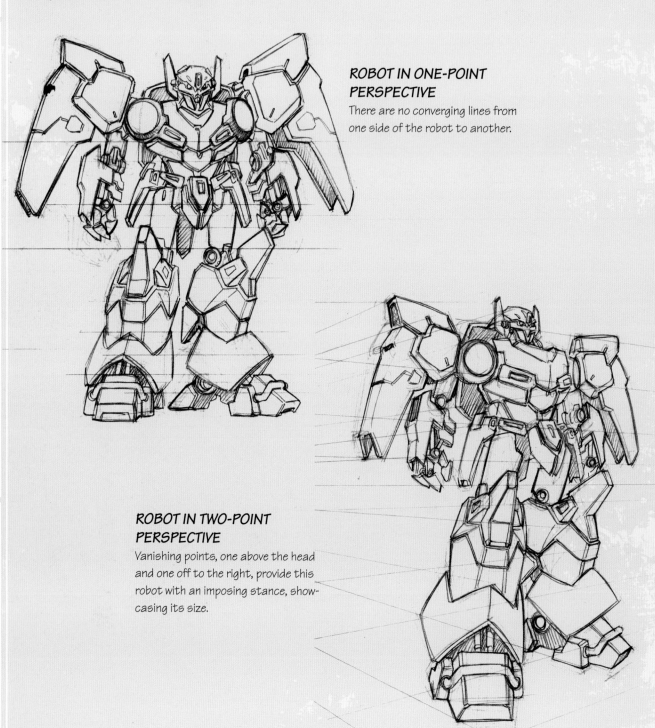

ROBOT IN ONE-POINT PERSPECTIVE

There are no converging lines from one side of the robot to another.

ROBOT IN TWO-POINT PERSPECTIVE

Vanishing points, one above the head and one off to the right, provide this robot with an imposing stance, showcasing its size.

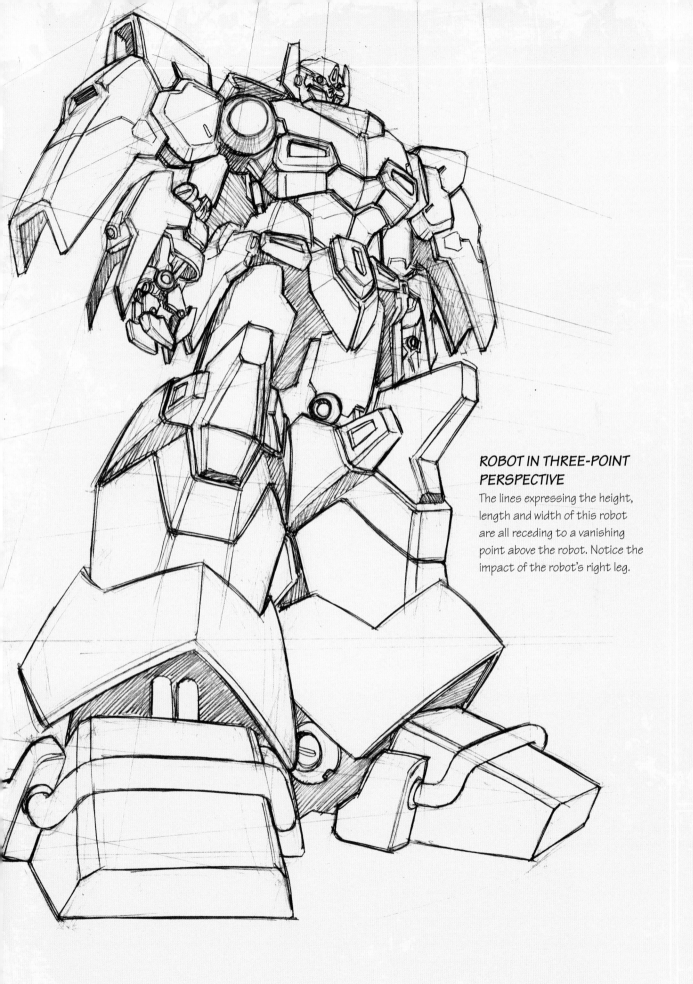

ROBOT IN THREE-POINT PERSPECTIVE

The lines expressing the height, length and width of this robot are all receding to a vanishing point above the robot. Notice the impact of the robot's right leg.

BIRD'S-EYE VIEW

A bird's-eye view is what you see when you view an object from a high vantage point toward the ground.

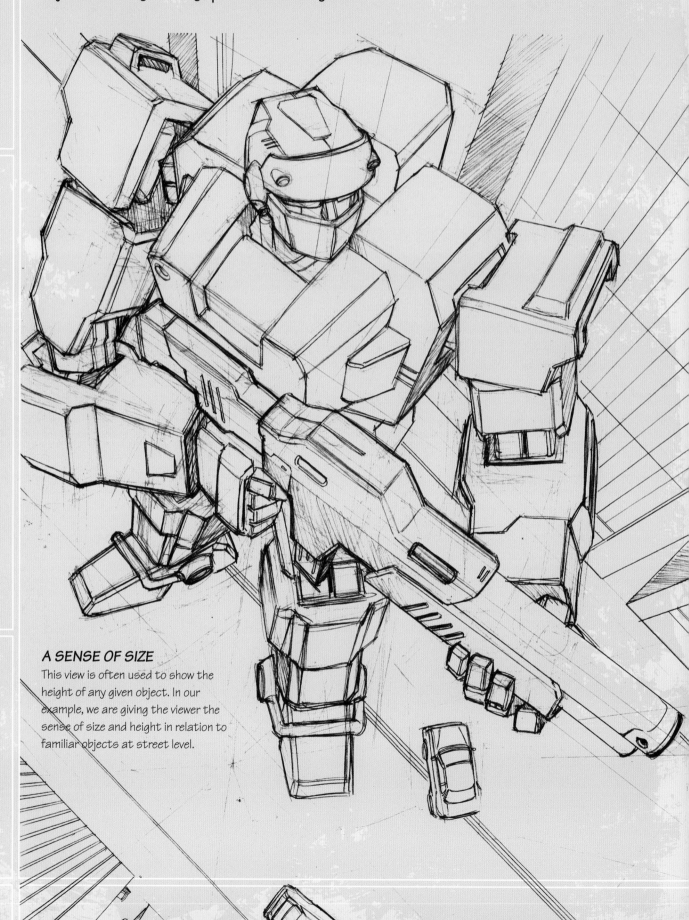

A SENSE OF SIZE

This view is often used to show the height of any given object. In our example, we are giving the viewer the sense of size and height in relation to familiar objects at street level.

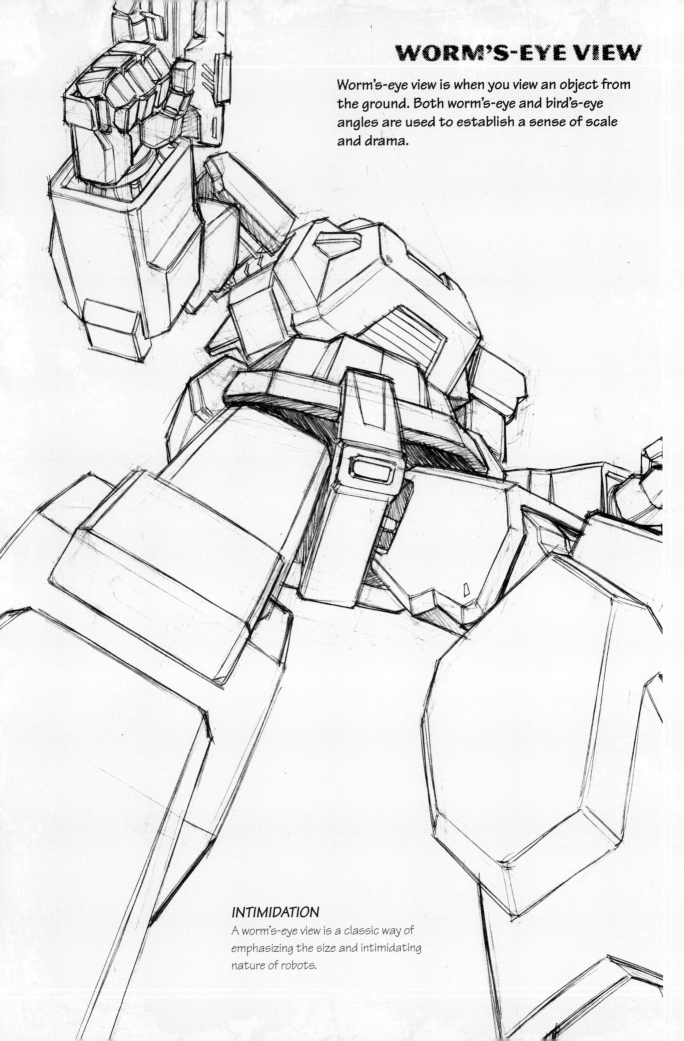

WORM'S-EYE VIEW

Worm's-eye view is when you view an object from the ground. Both worm's-eye and bird's-eye angles are used to establish a sense of scale and drama.

INTIMIDATION

A worm's-eye view is a classic way of emphasizing the size and intimidating nature of robots.

FORESHORTENING

Also known as "forced perspective," this angle pushes perspective to such an extreme that the figure or object appears distorted and the viewer gets the "in your face" sense of drama.

The foreground arm and leg are overextended.

The background arm and leg are overextended.

FORESHORTEN FOR DRAMA
The drawing above shows the correct way of using extreme foreshortening. The foreground and background limbs are foreshortened consistently.

AVOID OVEREXTENDED LIMBS
Artists often overextend the length of limbs when trying to force extreme perspective, making the limbs appear longer than they should. Mistakes are made more often on limbs that appear farther away from the viewer.

ROBOT IN FORCED PERSPECTIVE

The impact of the front hand is due to its extreme size in contrast with the rest of the body.

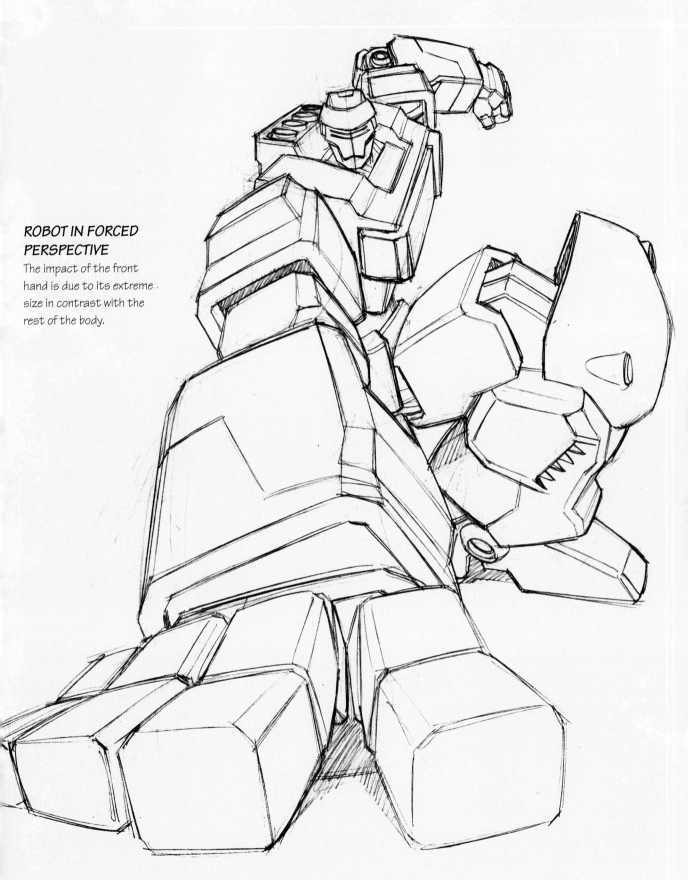

SKETCHING TECHNIQUES

Before we get into actually drawing robots, it's essential that you learn a few good habits for sketching. Even skilled artists can end up with unsatisfactory sketches. Correct your bad habits now and you'll be ready to sketch the robots you imagine.

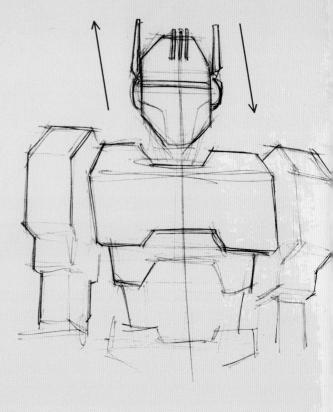

DISTORTED VISION

If your artwork appears lopsided, it could be that you are drawing on a flat surface. When you do that, your eyes aren't looking at the artwork straight on.

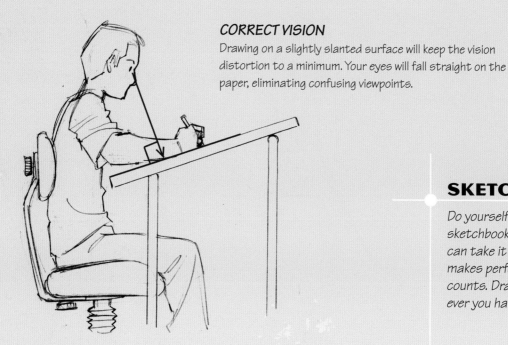

CORRECT VISION

Drawing on a slightly slanted surface will keep the vision distortion to a minimum. Your eyes will fall straight on the paper, eliminating confusing viewpoints.

SKETCH OFTEN

Do yourself a favor; pick up a sketchbook small enough so you can take it everywhere. Practice makes perfect, and mileage counts. Draw whenever and wherever you have time.

USE LONG STROKES INSTEAD OF SHORT STROKES

One of the best ways to keep sketches clean is to use long strokes. Long strokes not only help keep sketches clean, but also help you focus on overall shape and form rather than on a small portion of a drawing. I always start sketching with a very light stroke, sometimes barely touching the paper. It requires practice, but it's worth the effort.

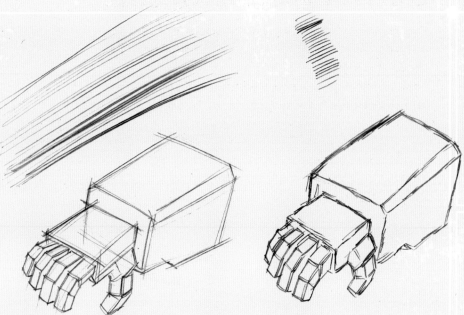

DRAW CURVES

Humans are designed to draw curves, not straight lines. Keep your strokes perpendicular to your drawing arm. Curves can be easily drawn when the arm is acting as a compass, with the elbow as the pivot. Turn your paper often so the strokes that you're making favor this comfortable way to sketch.

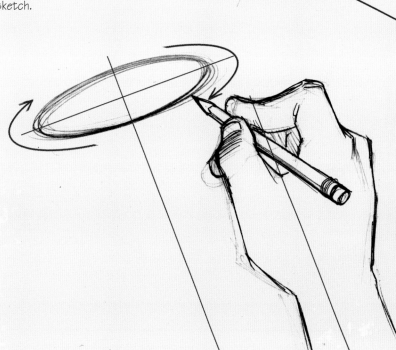

SKETCH ELLIPSES

Ellipses take some practice. Keep your drawing arm perpendicular to the ellipse's major axis.

LIGHTING AND SHADING

Lighting and shading are subjects all on their own, but with our limited space we'll only go into the basics. Look around and pay attention to how light affects the objects around you, and how the objects act and react to each other. Nature is our best teacher—study it!

LIGHTING ON A CUBE ↓

In this example, the light comes from upper left-hand corner. The top side of the cube receives direct light, and the light side of the cube receives partial light. The shadow side receives no direct lighting and creates a drop shadow on the side opposite of the light.

The closer the cube gets to the light source the lighter it gets, right? Not quite. The ground reflects light onto adjacent surfaces. The bottom of the light side is a bit lighter because of the reflected light. Even though the shadow side is completely in shadow, it still receives plenty of reflected light from the ground.

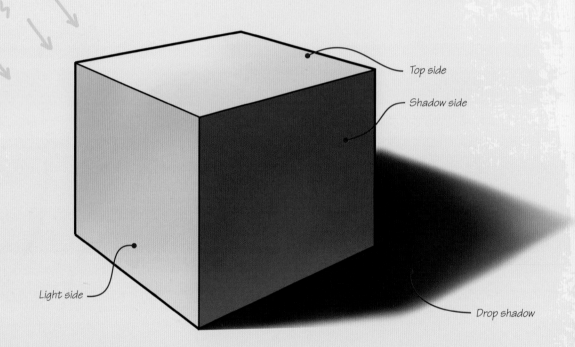

Top side

Shadow side

Light side

Drop shadow

LIGHTING ON A CYLINDER

The shading here is similar to the cube, except the light and shadow sides are merged into one. In this case, a core shadow is clearly visible. It's the darkest part of the shadow side.

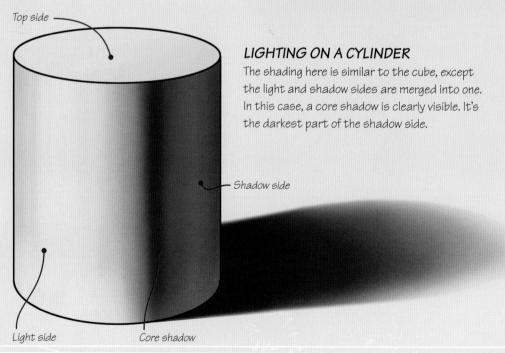

Top side

Shadow side

Light side Core shadow

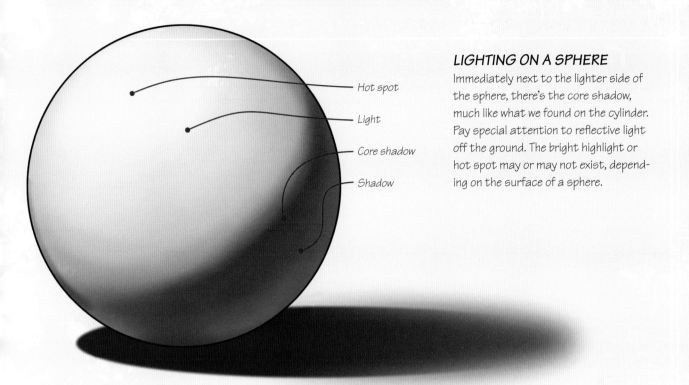

Hot spot

Light

Core shadow

Shadow

LIGHTING ON A SPHERE

Immediately next to the lighter side of the sphere, there's the core shadow, much like what we found on the cylinder. Pay special attention to reflective light off the ground. The bright highlight or hot spot may or may not exist, depending on the surface of a sphere.

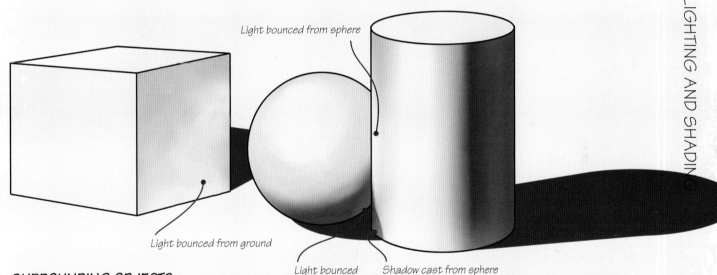

Light bounced from sphere

Light bounced from ground

Light bounced from cylinder

Shadow cast from sphere

SURROUNDING OBJECTS AFFECT LIGHTING

Objects affect lighting on other objects in the same setting. The objects receive reflected light not only from the ground, but also from each other.

STUDY LIGHT

Study lighting on actual objects. Go to an art supply store and pick up some primary shapes like a cube, sphere, cylinder and cone that are made of plaster. Place the shapes on a pure white surface, such as a tabletop or white sheet of paper. Find a lamp that lets you adjust the light's direction, and shine the light on the objects. It will work best if this lamp is the only light in the room. See how light reacts on the different shapes; this will help you show light and shadows accurately in your drawings.

LIGHTING AND SHADING: REFLECTIVE SURFACES

Dealing with robots and metal objects, eventually you will have to deal with highly reflective surfaces. This section shows you how basic reflection works.

CHROME CUBE

Chrome surfaces are, in essence, mirrored surfaces. A chrome cube is basically six square pieces of mirror stuck together. Let's place this chrome cube on a desert highway. The reflections on the cube are pretty straightforward. Each side reflects its facing environment directly.

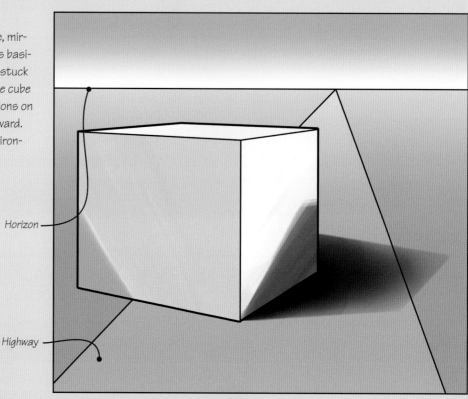

Horizon

Highway

STANDING CHROME CYLINDER

A reflection on a chrome cylinder tends to stretch the objects being reflected in one direction. On our example, the highway behind us is stretched from the bottom of the cylinder to the top. The reflections close to the sides of the cylinder are more compressed than in the middle. The highway ahead of us should barely appear on the bottom edge of the cylinder.

Highway ahead

Highway behind

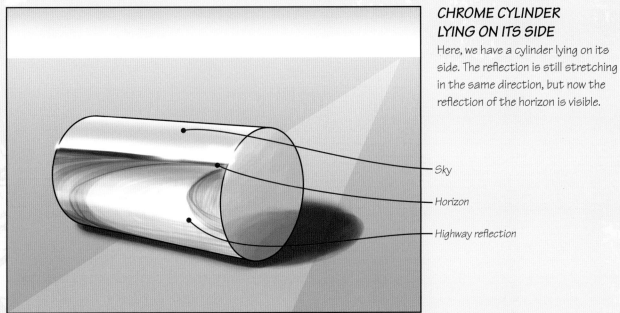

CHROME CYLINDER LYING ON ITS SIDE

Here, we have a cylinder lying on its side. The reflection is still stretching in the same direction, but now the reflection of the horizon is visible.

— Sky

— Horizon

— Highway reflection

CHROME SPHERE

With a chrome sphere, everything reflected has a "fish-eye lens" effect. Things are compressed toward the edge and magnified toward the center. We can clearly see the whole scene being reflected, but it is distorted.

— Hot spot

— Horizon

— Highway reflection

— Shadow reflection

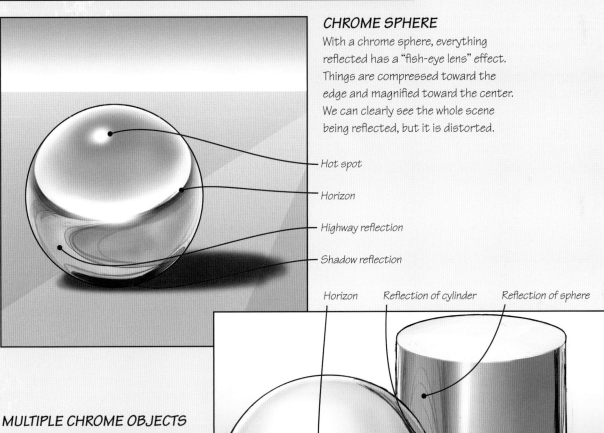

Horizon Reflection of cylinder Reflection of sphere

MULTIPLE CHROME OBJECTS

Drawing more than one chrome object in the same scene can be tricky because they are always reflecting off each other. In this example, we see the cylinder being reflected on the sphere and the sphere reflecting on the cylinder. Things can get confusing if we continue to add more objects into the same scene. The key to remember is that chrome reflects everything.

COLORING A ROBOT

This section is not meant to teach you how to color, but rather to show you the processes I normally go through as I apply color in a photo-editing program.

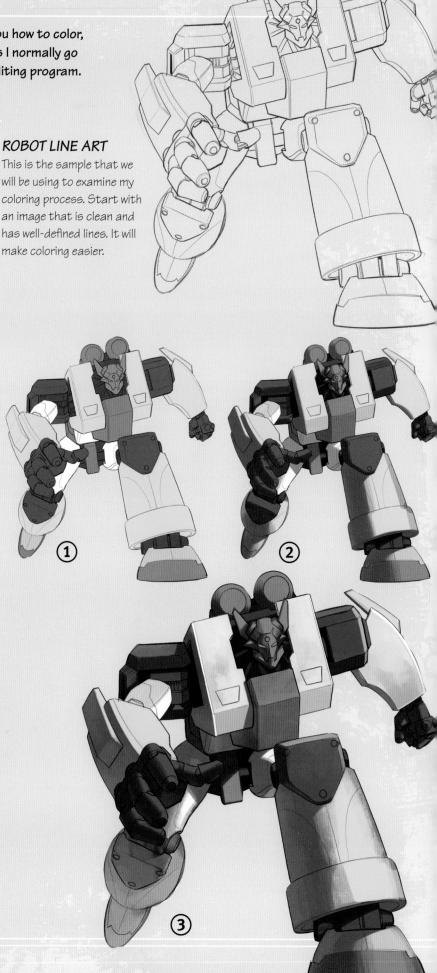

ROBOT LINE ART
This is the sample that we will be using to examine my coloring process. Start with an image that is clean and has well-defined lines. It will make coloring easier.

1 START WITH FLAT COLOR
Apply flat color on the different body parts. I have a habit of assigning slightly different colors to different pieces of the same color so I can quickly select different pieces even though they are in the same color scheme. For example, the right leg has the yellow tone on both shin and foot. I would normally give them slightly different colors so I could quickly select the foot without picking up the shin.

2 DEFINE SHADOW
I duplicate the flat color layer so I can color on the layer on top, but I could always go back to select the color pieces from the flat layer. At this stage, I create a shadow side on all the pieces for a rough idea of where light hits.

3 ADD COLOR DETAILS
This is where the most work comes in. Overall detail of each color piece is added, textures are painted and more detail is added to the shadow. Remember how we talked about light reflecting off one surface to another? This is a good example of how different colors affect each other.

4 ADD HIGHLIGHTS
If something is shiny, it has to have a highlight or "hot spot." In the final stage of the coloring process, the highlights are added to the colors.

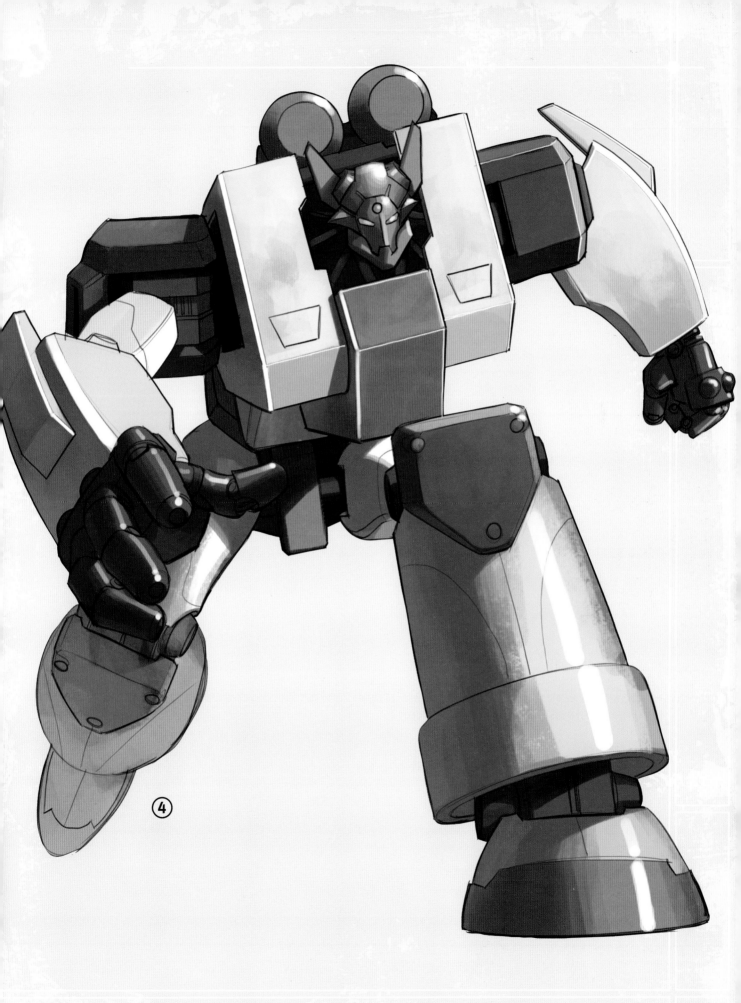

④

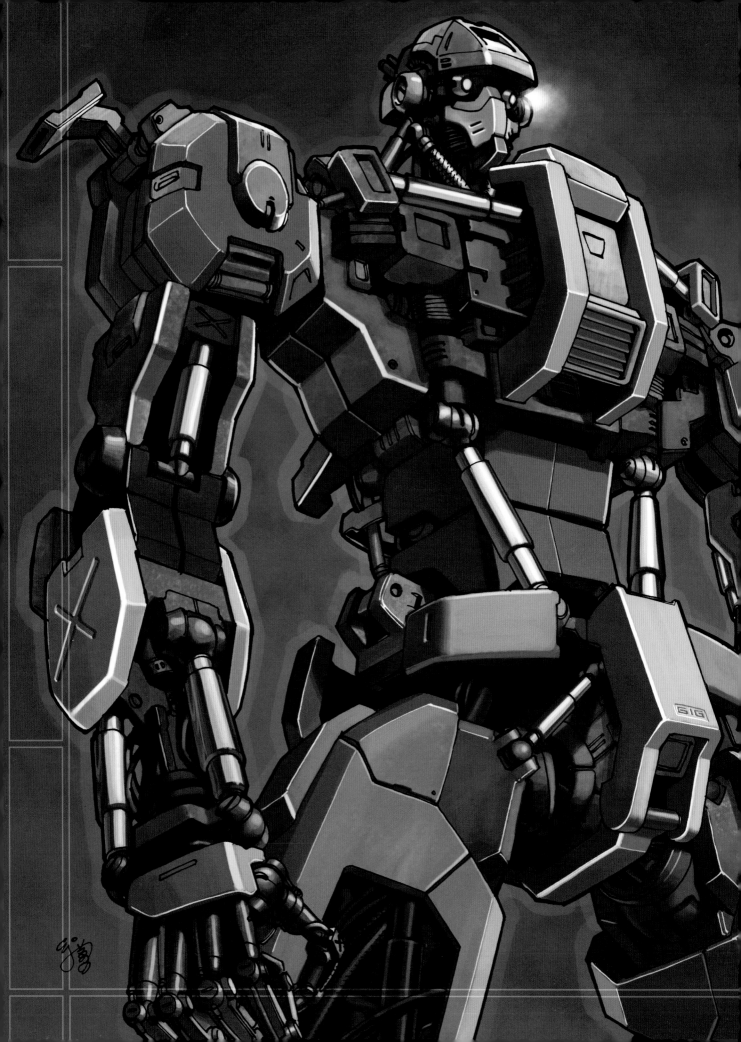

2. ROBOTIC ANATOMY

Robots are built and made to imitate life, and the majority of robots imitate humans in particular. Animals, including humans, in the living world are, in essence, very sophisticated machines. To create believable robots, use tubes, pipes, nuts, bolts, hydraulics and various other machinery parts to replace the muscles and bones that are in the natural world.

HEAD, NECK AND SHOULDERS

Neck movement becomes head movement. Robots need to have hydraulic shocks in place in order to emulate a human head's flexing and rotating.

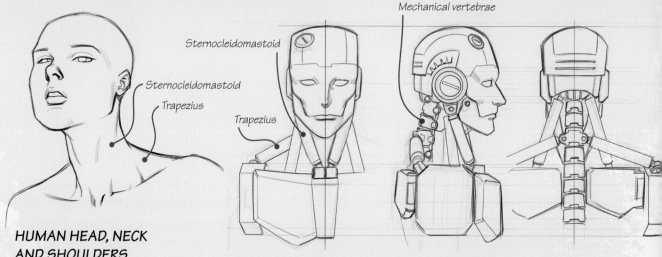

Mechanical vertebrae

Sternocleidomastoid

Sternocleidomastoid

Trapezius

Trapezius

HUMAN HEAD, NECK AND SHOULDERS

The sternocleidomastoid and trapezius are the pieces of muscle around the neck and shoulder area that allow head movement.

MECHANICAL HEAD, NECK AND SHOULDERS

The hydraulics here emulate the sternocleidomastoid and trapezius. They contract and expand in conjunction with the bending mechanical vertebrae, allowing movement that is similar to a human neck.

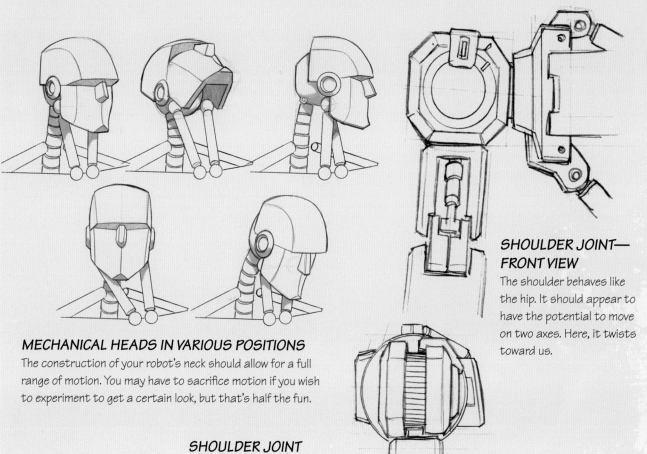

MECHANICAL HEADS IN VARIOUS POSITIONS

The construction of your robot's neck should allow for a full range of motion. You may have to sacrifice motion if you wish to experiment to get a certain look, but that's half the fun.

SHOULDER JOINT— FRONT VIEW

The shoulder behaves like the hip. It should appear to have the potential to move on two axes. Here, it twists toward us.

SHOULDER JOINT —SIDE VIEW

Here, we can view the potential for the arm to move up and out.

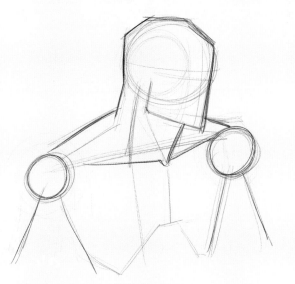

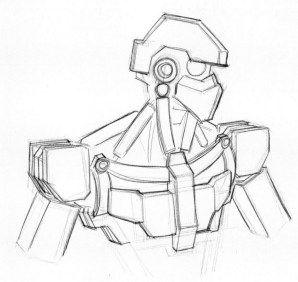

1 DRAW A ROUGH OUTLINE

Start with a very sketchy, almost stick figurelike rough pose. You want to keep the strokes long, straight and very light. At this stage, my pencil is usually barely touching the paper. In fact, you will barely see these strokes; this sample line art is enhanced to show the strokes better. It's very important at this stage to work out the proper posture and proportion. Correction at this stage is easiest; lines are easy to erase and you haven't wasted too much time on something that doesn't work.

2 DRAW BASIC SHAPES

At this stage, everything is still rough, mostly in rough boxes and tubes, and various shapes that would make up the overall shape of the robot. This is the stage to work out the relationships between components to make sure every joint, pipe, tube and metal box is working like it should. Strokes should still be kept relatively light.

IMITATORS OF LIFE

Strip away the armor and outer shell to see that robots are like all living things in the world. They require sophisticated machinery to give them the freedom of movement that imitates life.

3 ADD DEFINING LINES AND DETAILS

Go over all the rough lines and give them definite definition, and throw in details to spice up the artwork.

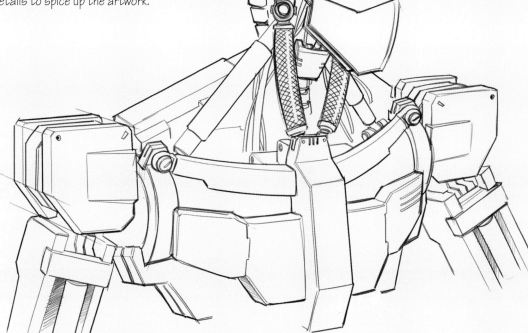

TORSO

Our goal here is to emulate the human torso's range of movement with mechanical components. Dividing the torso into chest, rib cage, abdominal and hip sections will give our robot the maximum movement possible.

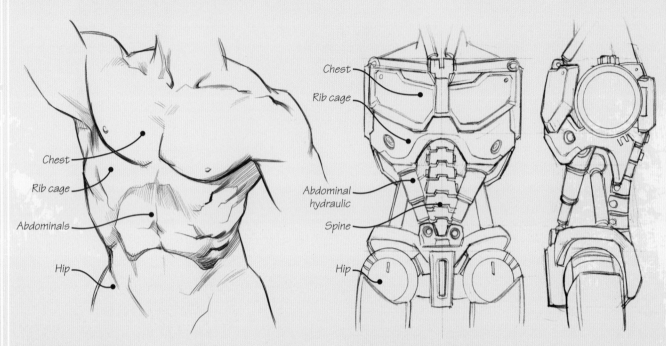

Chest
Rib cage
Abdominals
Hip

Chest
Rib cage
Abdominal hydraulic
Spine
Hip

HUMAN TORSO

The torso is made up of four parts, which all move in relation to each other. It's helpful to break down the torso into these parts in order to draw them. The abdominals are the most flexible part of the torso, but a lot of muscle groups are working together with the spine to make us bend and flex our torso.

MECHANICAL TORSO

I chose to implement a couple of major hydraulic connections between the rib cage and hip to act as abdominal muscles. Notice how the four parts are represented here. The spine is visible because, unlike us, the robot has no skin.

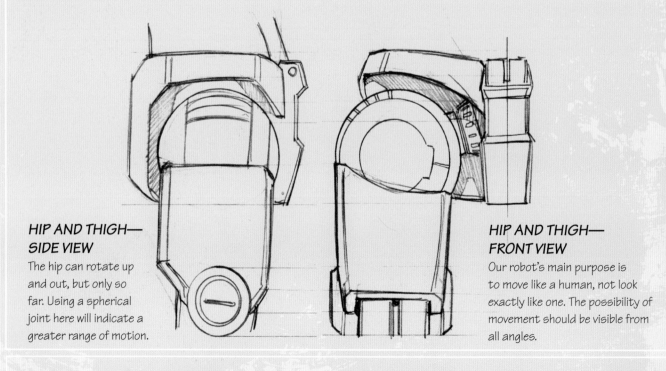

HIP AND THIGH— SIDE VIEW

The hip can rotate up and out, but only so far. Using a spherical joint here will indicate a greater range of motion.

HIP AND THIGH— FRONT VIEW

Our robot's main purpose is to move like a human, not look exactly like one. The possibility of movement should be visible from all angles.

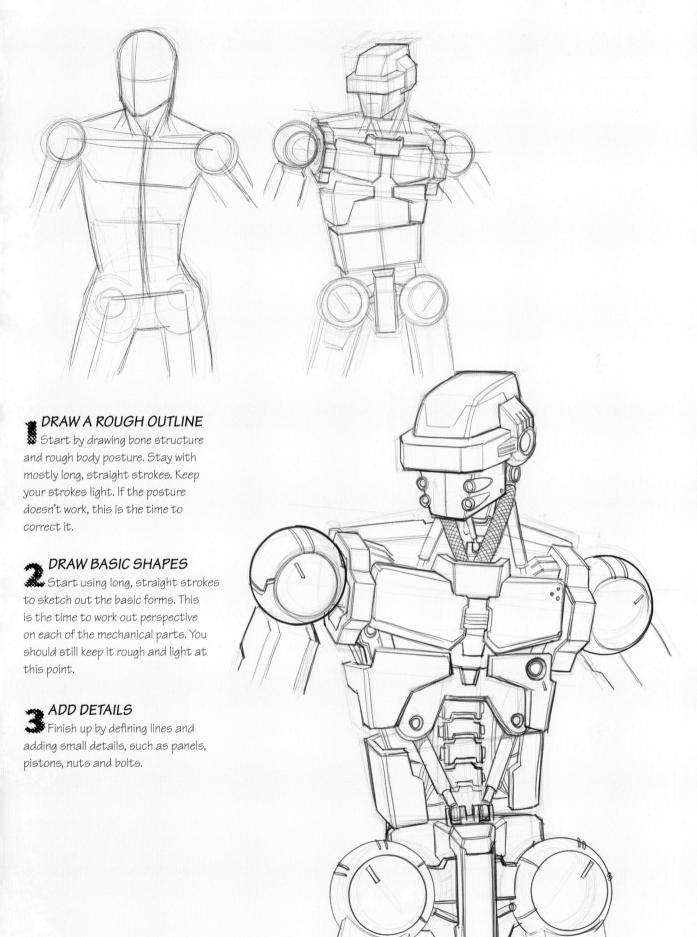

1 **DRAW A ROUGH OUTLINE**
Start by drawing bone structure and rough body posture. Stay with mostly long, straight strokes. Keep your strokes light. If the posture doesn't work, this is the time to correct it.

2 **DRAW BASIC SHAPES**
Start using long, straight strokes to sketch out the basic forms. This is the time to work out perspective on each of the mechanical parts. You should still keep it rough and light at this point.

3 **ADD DETAILS**
Finish up by defining lines and adding small details, such as panels, pistons, nuts and bolts.

ARMS

Due to the large range of movement at the shoulder, this is one of the more complicated areas of the human body to mechanize. Rotary joints in conjunction with hydraulics are required to emulate enough of the movement. We will have more detail of the shoulder joint on page 47.

more detail of the shoulder joint on page 47.

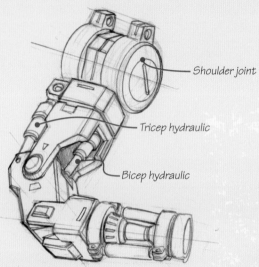

HUMAN ARM

The deltoid muscle controls the raising and the dropping of the arm. Triceps and biceps control the flexing of the forearm. When bicep contracts, the forearm folds up. When the tricep contracts, the forearm extends.

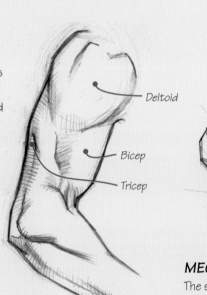

Deltoid

Bicep

Tricep

Shoulder joint

Tricep hydraulic

Bicep hydraulic

MECHANICAL ARM

The shoulder and elbow joints should look different because they have different ranges of motion. The shoulder is more sophisticated.

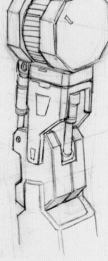

ELBOW HYDRAULIC— RELAXED

In a relaxed position, the tricep piston recedes into the mass of the upper arm.

ELBOW HYDRAULIC— FLEXED

Extension of the tricep piston along with the recession of the bicep piston causes the elbow joint to bend.

MECHANICAL FOREARM— RELAXED

The circular nature of the forearm reminds us that it is used to twist the hand.

MECHANICAL FOREARM— ROTATING

Since humans have limited forearm rotation, two hydraulic shocks prevent an overextension of the forearm.

ARMS

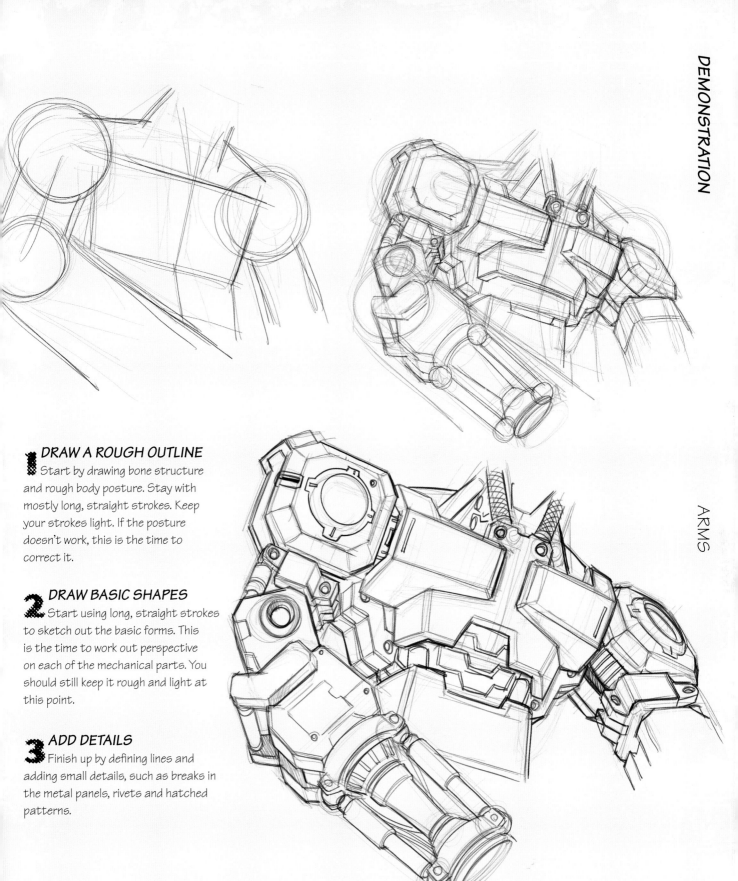

1 DRAW A ROUGH OUTLINE
Start by drawing bone structure and rough body posture. Stay with mostly long, straight strokes. Keep your strokes light. If the posture doesn't work, this is the time to correct it.

2 DRAW BASIC SHAPES
Start using long, straight strokes to sketch out the basic forms. This is the time to work out perspective on each of the mechanical parts. You should still keep it rough and light at this point.

3 ADD DETAILS
Finish up by defining lines and adding small details, such as breaks in the metal panels, rivets and hatched patterns.

HANDS AND FINGERS

A human hand is a complex machine within itself. The hands need to be agile, active and nimble. The more active and the greater range of motion a body part has, the bigger the problem it presents when it comes to duplicating its function mechanically.

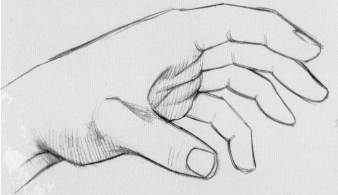

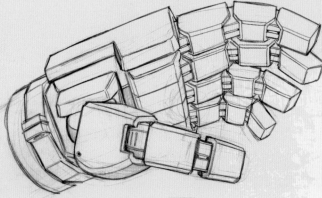

HUMAN HAND
The hand is heavily jointed and any representation of it should reflect this.

MECHANICAL HAND
A robot hand should play up the joints within the structure. This will make it easier to see an ability to move.

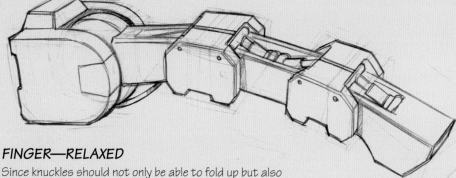

FINGER—RELAXED
Since knuckles should not only be able to fold up but also be able to move laterally, a ball-bearing joint is used on the knuckles. Casing around the ball limits the range of movement on the knuckle to prevent hyperextension.

Every finger joint has small hydraulics to control the contraction and extension of the finger.

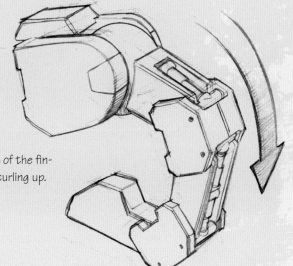

FINGER—FLEXED
Extending the hydraulics of the finger results in the finger curling up.

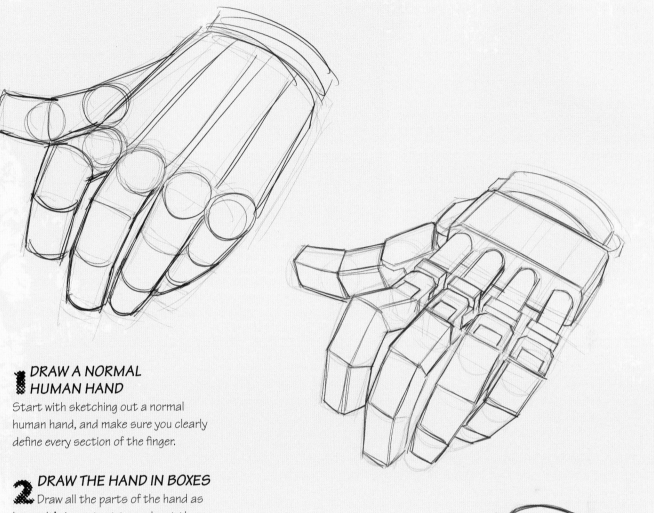

1 DRAW A NORMAL HUMAN HAND

Start with sketching out a normal human hand, and make sure you clearly define every section of the finger.

2 DRAW THE HAND IN BOXES

Draw all the parts of the hand as boxes. It's important to work out the correct perspective on every section of the finger. You'll need the perspective correct to go on to the next stage. It may seem overwhelming at first, but you'll be better off if you focus on one finger, or one section of the finger, at a time.

3 DRAW MECHANICAL DETAILS

This step takes the perspective one step further. Build irregularly shaped pieces on top of the perspective that you established in the previous step. Again, it is much easier if you focus on one section of the hand at a time.

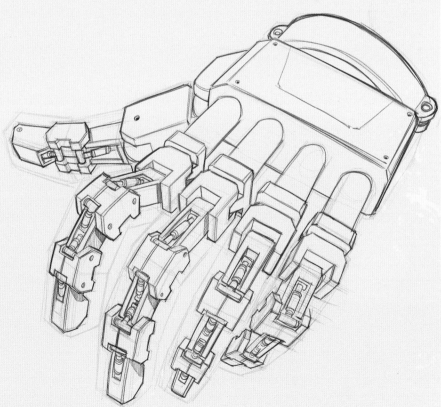

ROBOTIC HAND VARIATIONS

Robotic hands can be anything you can think of, not always typical humanlike hands. This section will show you a variety of different types of hands. Use them as examples. Then let your imagination run wild and come up with something totally different.

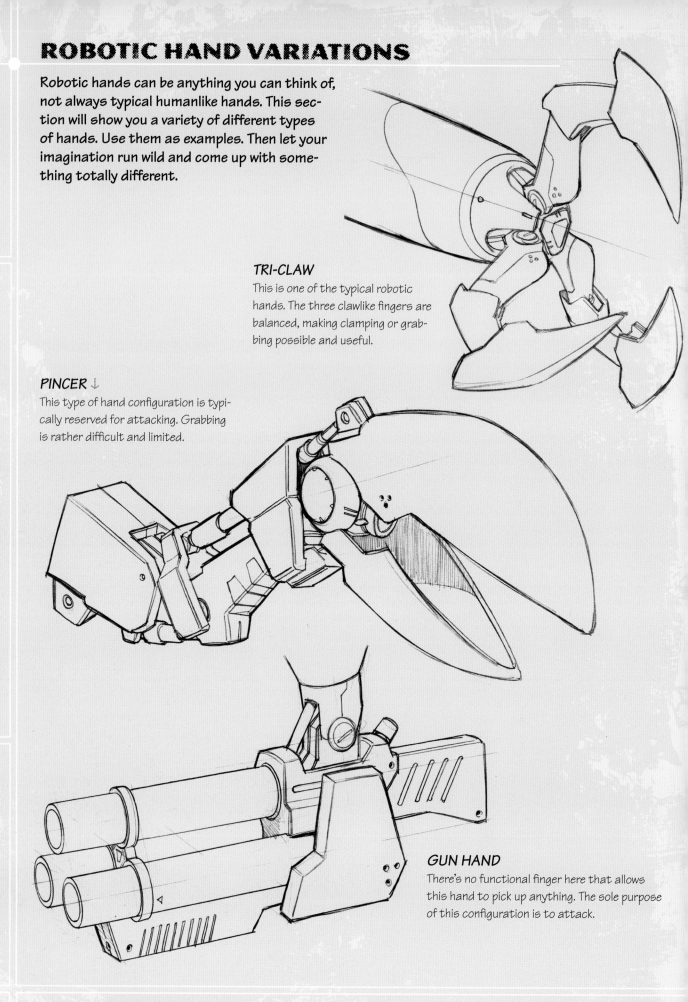

TRI-CLAW
This is one of the typical robotic hands. The three clawlike fingers are balanced, making clamping or grabbing possible and useful.

PINCER ↓
This type of hand configuration is typically reserved for attacking. Grabbing is rather difficult and limited.

GUN HAND
There's no functional finger here that allows this hand to pick up anything. The sole purpose of this configuration is to attack.

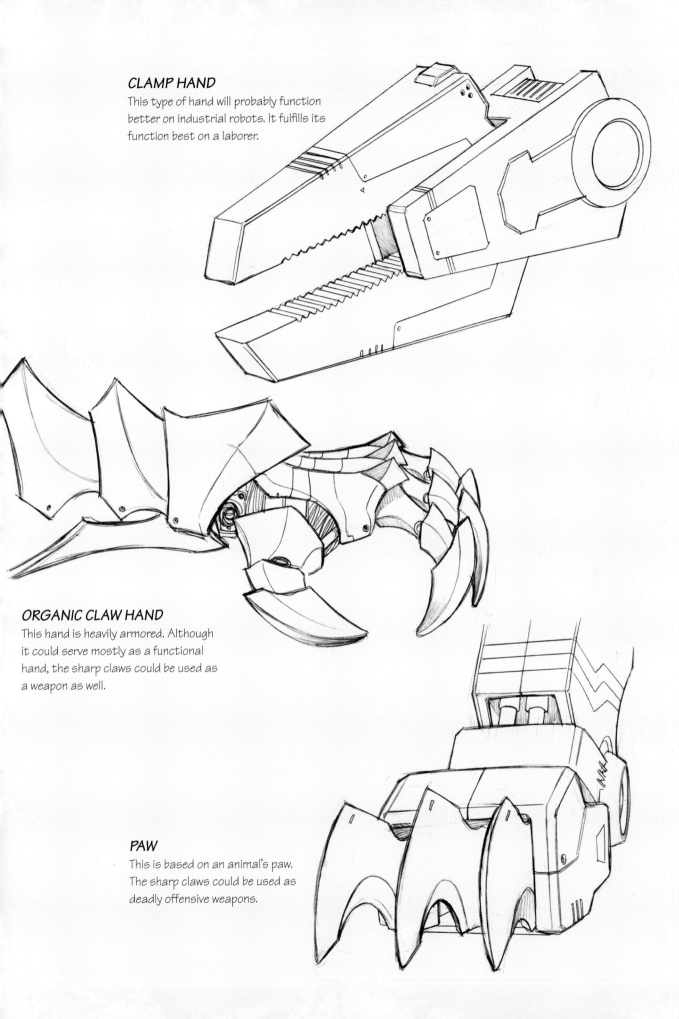

CLAMP HAND

This type of hand will probably function better on industrial robots. It fulfills its function best on a laborer.

ORGANIC CLAW HAND

This hand is heavily armored. Although it could serve mostly as a functional hand, the sharp claws could be used as a weapon as well.

PAW

This is based on an animal's paw. The sharp claws could be used as deadly offensive weapons.

LEGS AND FEET

Legs serve as the platform and engine of any bipedal organism. Bipedal robotic feet are one of the most difficult things to accomplish realistically. Millions of nerves and muscles are working to compensate for each other in order for a human to stand, walk, run and do other activities. Fortunately, robots need only our imaginations.

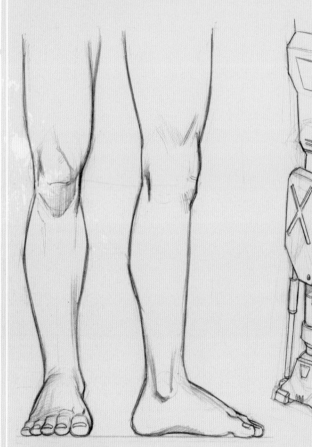

KNEE AND ANKLE RANGES OF MOTION

Though the leg can be in countless positions, it only has two points of movement within itself: the knee joint and the ankle joint.

MECHANICAL LEG

This is the robotic leg in a relaxed position. Just like all the other joints, the bending of the knee and ankle is powered by hydraulics.

HUMAN LEG

For humans, the leg makes up more than half of the body. Their size should reflect the amount of upper body weight they must support.

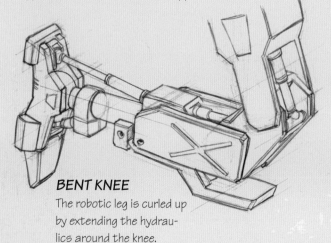

BENT KNEE

The robotic leg is curled up by extending the hydraulics around the knee.

ANKLE

The ankle needs to rotate in more than one direction; therefore, a ball bearing is used here. The purpose of the twin hydraulics in front is to control the rotation of the ball joint.

FOOT PUSHING OFF

The tendon in the back contracts and the twin hydraulics in front extend while the foot is pushing off.

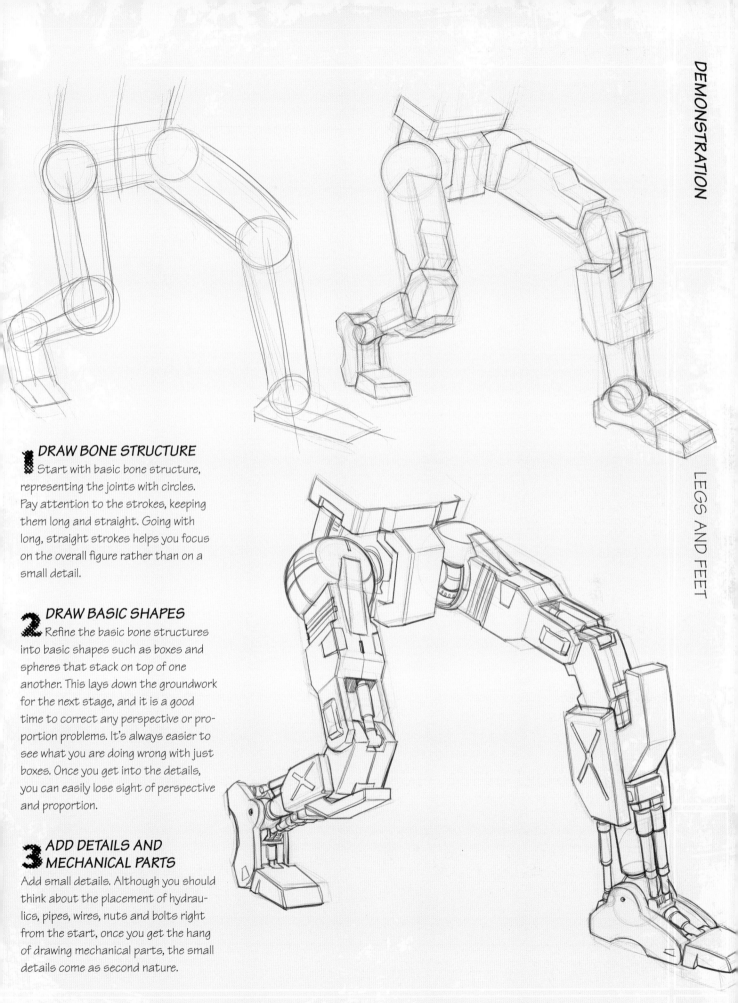

1 DRAW BONE STRUCTURE

Start with basic bone structure, representing the joints with circles. Pay attention to the strokes, keeping them long and straight. Going with long, straight strokes helps you focus on the overall figure rather than on a small detail.

2 DRAW BASIC SHAPES

Refine the basic bone structures into basic shapes such as boxes and spheres that stack on top of one another. This lays down the groundwork for the next stage, and it is a good time to correct any perspective or proportion problems. It's always easier to see what you are doing wrong with just boxes. Once you get into the details, you can easily lose sight of perspective and proportion.

3 ADD DETAILS AND MECHANICAL PARTS

Add small details. Although you should think about the placement of hydraulics, pipes, wires, nuts and bolts right from the start, once you get the hang of drawing mechanical parts, the small details come as second nature.

JOINTS

I believe joints are the heart and soul of drawing a good robot. Unless you understand how things work, you can't do a good enough job of drawing it. One of the most complicated mechanical issues on a robot is figuring out how a joint rotates correctly.

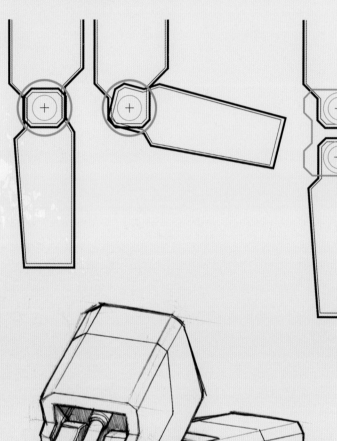

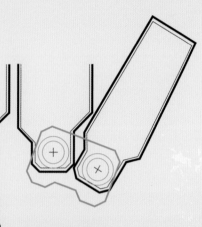

ELBOW JOINT

This is a simple graphic representation of how an elbow should bend, and the range of motion it needs to emulate human motion. The traditional single joint elbow usually doesn't work well because the rotation of the joint is restricted. Double joints are a much preferred configuration because they allow optimum range of motion.

DOUBLE-JOINTED ELBOW

This is a close-up of the double-jointed elbow. Hydraulics are required on both joints in order to work correctly.

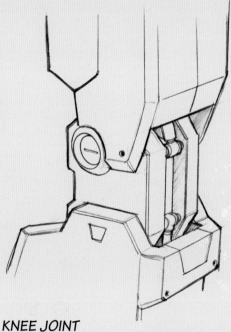

KNEE JOINT

The same type of principle in the elbow joint applies to the knee joint. A double joint is a more effective configuration, especially for the knee. More often than not, the mass of the leg makes it almost impossible to have a single-jointed knee.

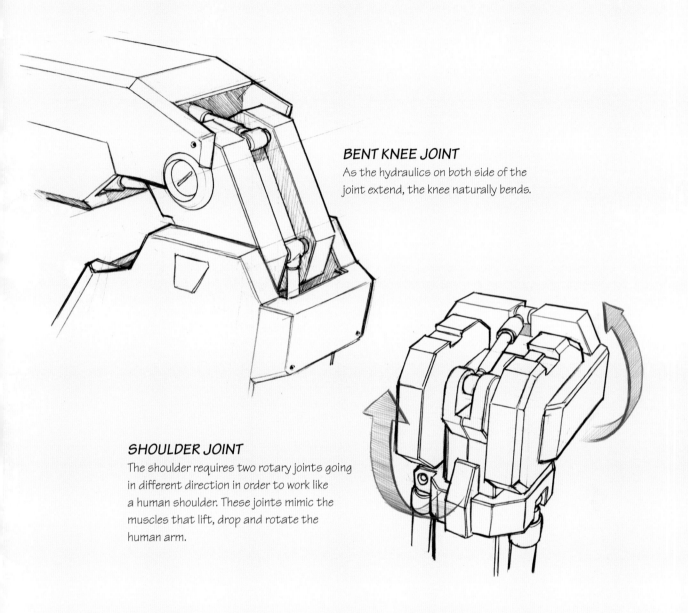

BENT KNEE JOINT

As the hydraulics on both side of the joint extend, the knee naturally bends.

SHOULDER JOINT

The shoulder requires two rotary joints going in different direction in order to work like a human shoulder. These joints mimic the muscles that lift, drop and rotate the human arm.

THE 360° JOINT

A ball-bearing joint is a simple way to express a joint that has a near-limitless range of motion. However, it is structurally weak. Attaching large, imposing robot parts to this joint may make the drawing unbelievable and less interesting. Play with a joint's construction to make it suit your drawing.

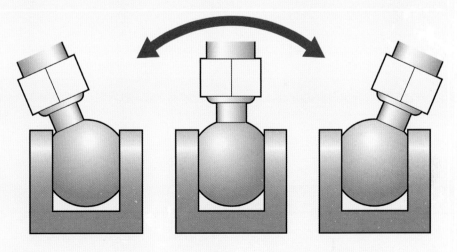

ROBOTIC BODY TYPE VARIATIONS

Robots are not just slim, slick and athletic. They can be fat, thin, exaggerated or have a feminine appearance.

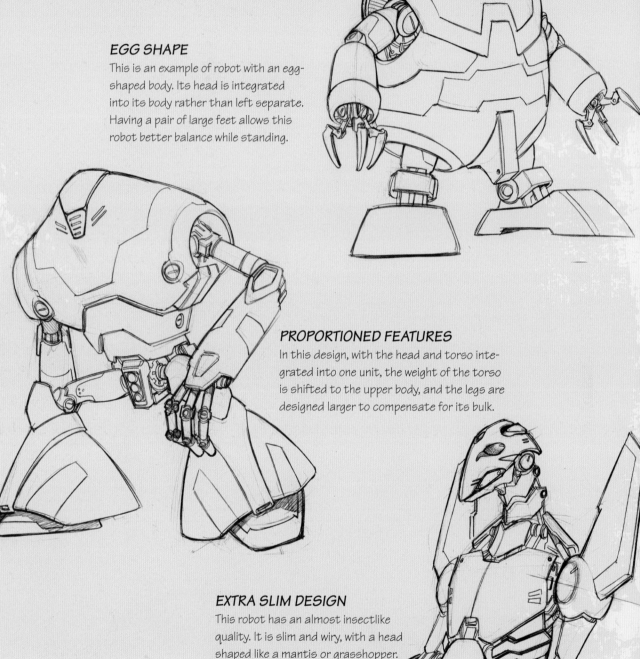

EGG SHAPE
This is an example of robot with an egg-shaped body. Its head is integrated into its body rather than left separate. Having a pair of large feet allows this robot better balance while standing.

PROPORTIONED FEATURES
In this design, with the head and torso integrated into one unit, the weight of the torso is shifted to the upper body, and the legs are designed larger to compensate for its bulk.

EXTRA SLIM DESIGN
This robot has an almost insectlike quality. It is slim and wiry, with a head shaped like a mantis or grasshopper.

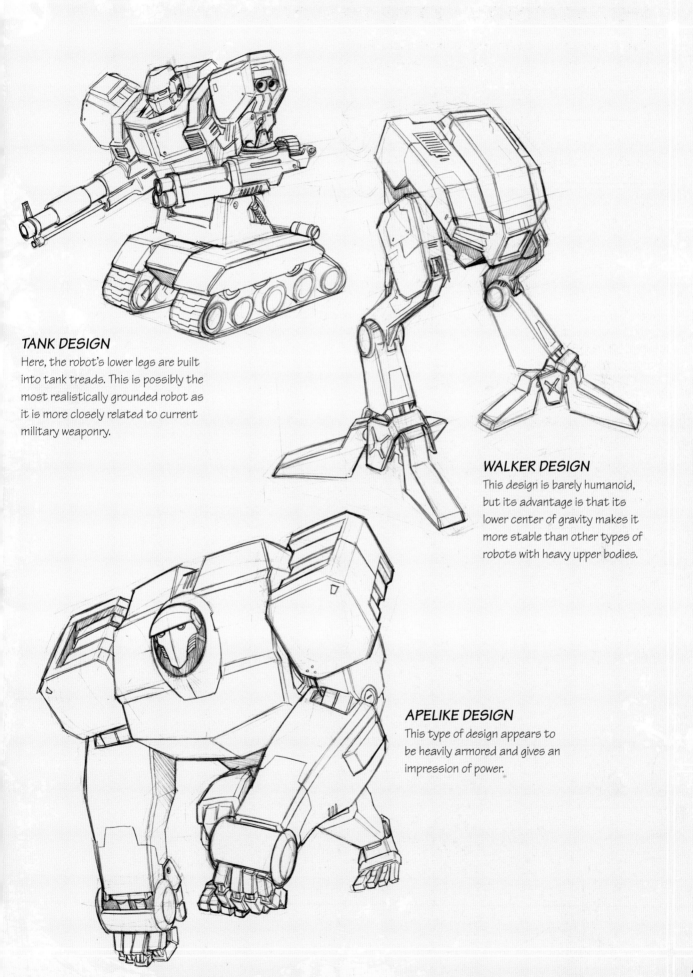

TANK DESIGN

Here, the robot's lower legs are built into tank treads. This is possibly the most realistically grounded robot as it is more closely related to current military weaponry.

WALKER DESIGN

This design is barely humanoid, but its advantage is that its lower center of gravity makes it more stable than other types of robots with heavy upper bodies.

APELIKE DESIGN

This type of design appears to be heavily armored and gives an impression of power.

NONHUMANOID ROBOTS

Robots are simply imitations of life and nature. You can find a lot of design inspiration in other creatures.

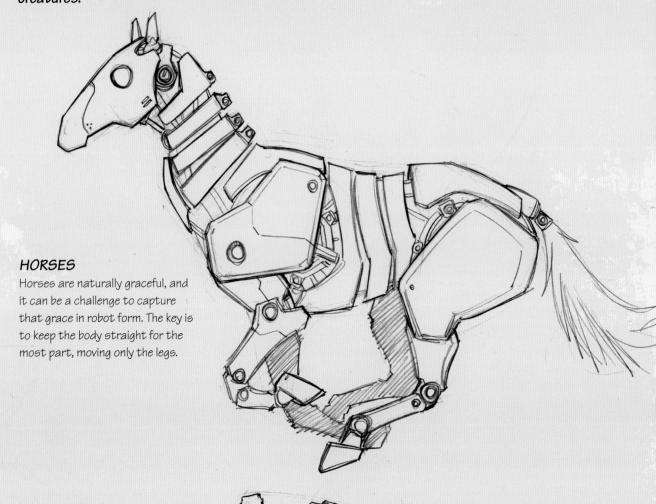

HORSES
Horses are naturally graceful, and it can be a challenge to capture that grace in robot form. The key is to keep the body straight for the most part, moving only the legs.

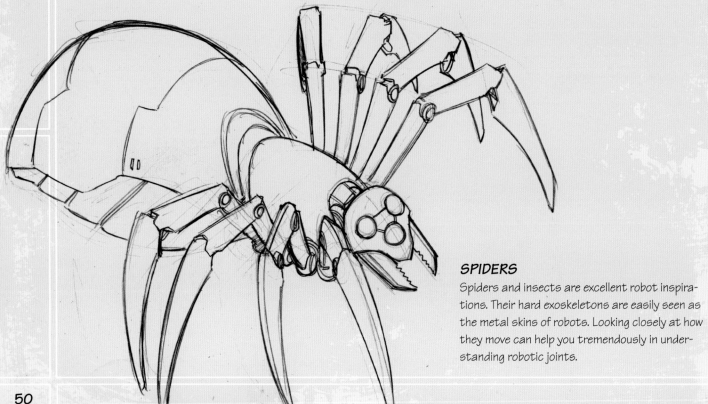

SPIDERS
Spiders and insects are excellent robot inspirations. Their hard exoskeletons are easily seen as the metal skins of robots. Looking closely at how they move can help you tremendously in understanding robotic joints.

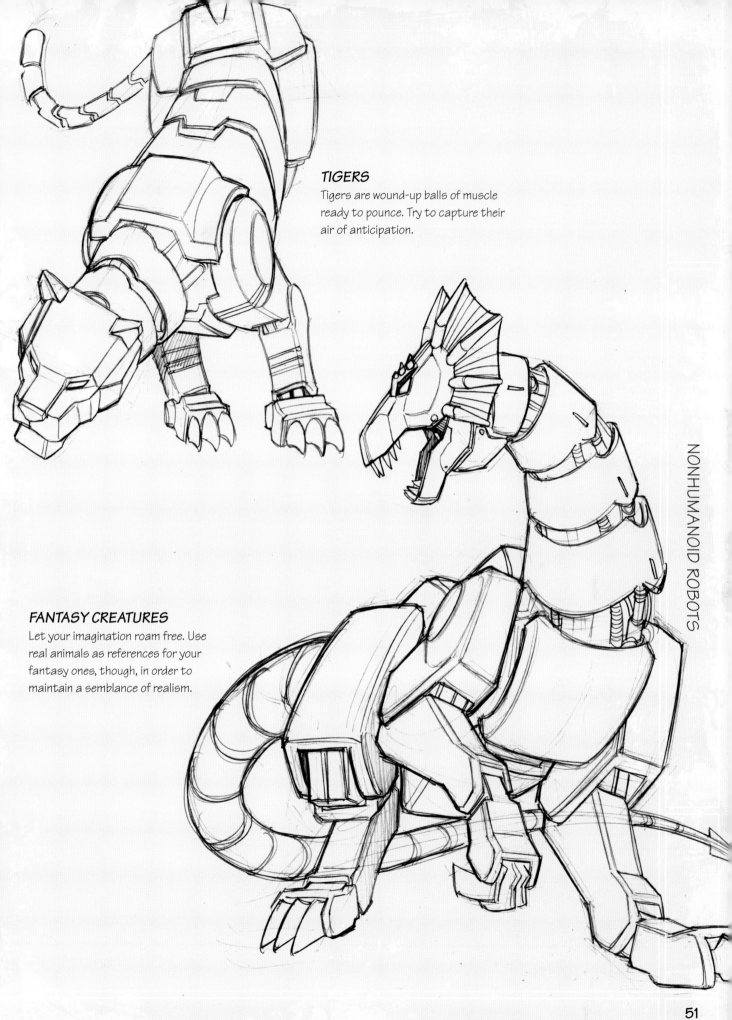

TIGERS

Tigers are wound-up balls of muscle ready to pounce. Try to capture their air of anticipation.

FANTASY CREATURES

Let your imagination roam free. Use real animals as references for your fantasy ones, though, in order to maintain a semblance of realism.

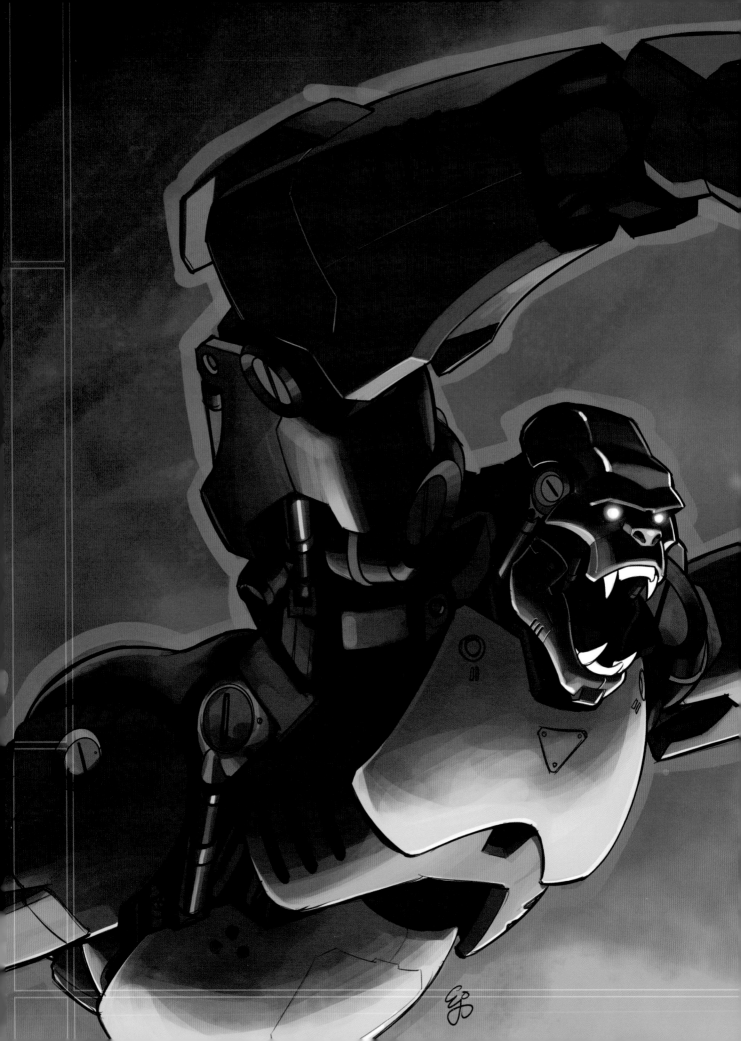

3 DRAWING ROBOTS

This chapter will show you samples of how I approach drawing a robot from different angles and in different poses, as well as how to construct a scene.

HUMANOID ROBOT ONE: FRONT VIEW

Humanoid robots are consructed like humans. They have two legs and two arms. The hard angles of the shapes make the form robotic.

1 CREATE SKELETAL STRUCTURE

Lay down the foundation of the robot, making sure your proportions are correct. Remember to keep the strokes light, long and straight. Use the joints as reference points. In this view, keep the shoulders, hips and knees aligned horizontally.

2 ADD BASIC SHAPES

Adding basic shapes is the most important stage of your drawing. Add shapes to give volume to your skeleton. Use three-dimensional boxes, drawing them in perspective. Separate the chest, ribs, abdominals and hips into parts that look like they can move. Remember, most joints only rotate or bend in one direction. Pay special attention to the elbows and knees.

3 DRAW ROUGH DETAILS

Add details to the existing shapes. Surface patterns and lines will add interest to your boxes. Elbows and shoulders are good places to add mechanical extensions. They can represent weapons or other special equipment.

4 INK SHAPES AND DETAILS

Choose the details you want to make absolutely clear. Go over your drawing with an ink pen. Add shadows in places hidden from clear view and hatchmarks in places where a shadow is implied. Keep your light constant; in this case, from above. This robot has many details in groups of three, adding continuity to the design.

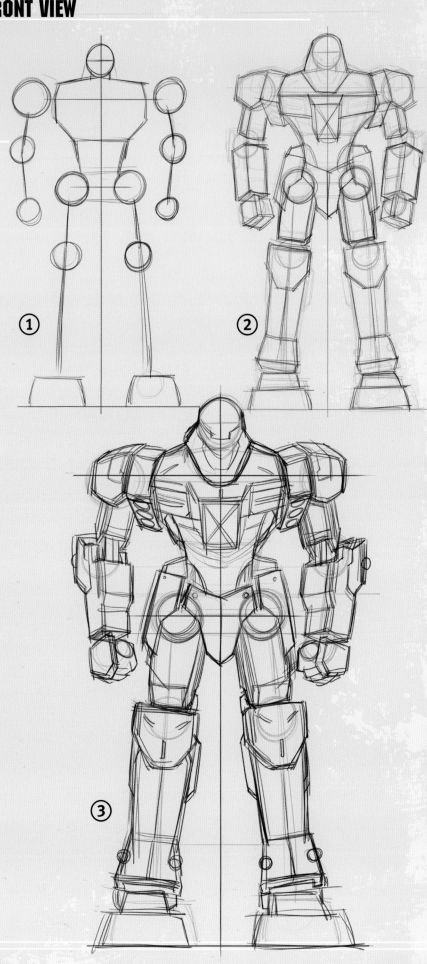

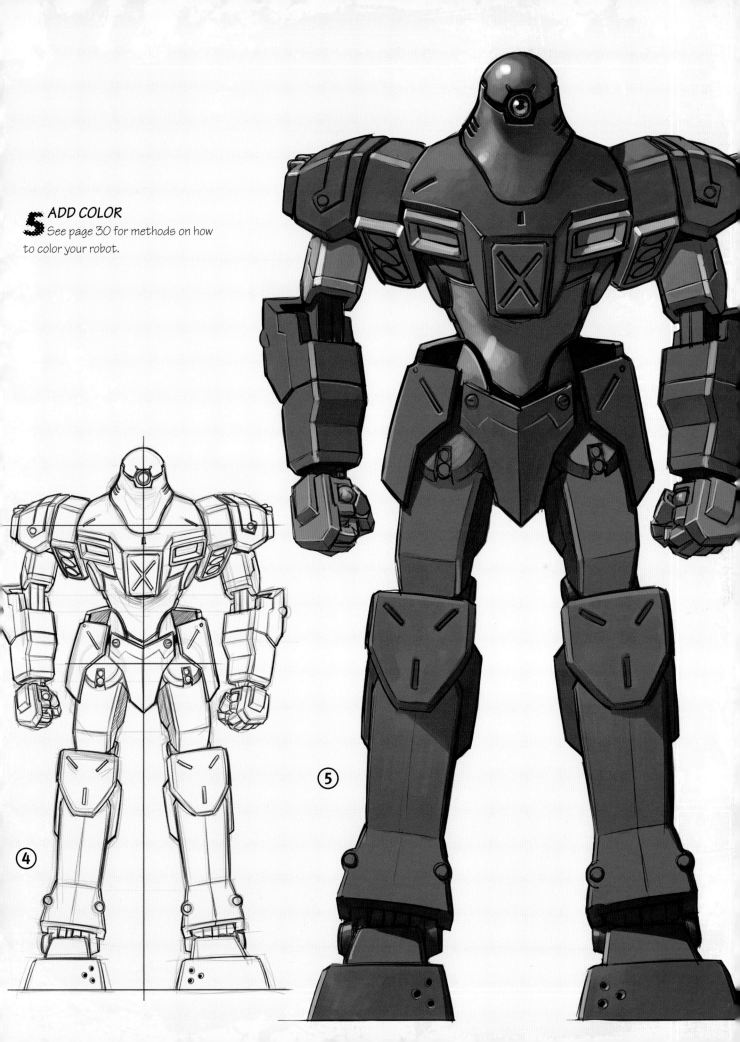

5 ADD COLOR
See page 30 for methods on how to color your robot.

④

⑤

HUMANOID ROBOT ONE: THREE-QUARTER VIEW

1 CREATE SKELETAL STRUCTURE
Draw the basic skeletal structure. In this view, pay attention to the way the robot stands. The foot and shoulder that are farther away appear higher than their counterparts. Plan out your skeletal structure, keeping the parts in proportion. Use the joints as guides.

2 ADD BASIC SHAPES
Pay special attention to the elbows and knees. Because the robot is turned, it is no longer symmetrical. Practice roughing in the shapes correctly to represent the different parts at this new angle. Take your time. This is not easy. Use long, straight strokes, keeping them light.

3 DRAW ROUGH DETAILS
Following the edges you mapped out in step 2, add the surface details. Use the basic shapes as guidelines.

4 INK SHAPES AND DETAILS
Complete the details, giving them depth and volume with shadow. Use thick lines for the major shapes and thin lines for the details.

5 ADD COLOR
See page 30 for methods on how to color your robot.

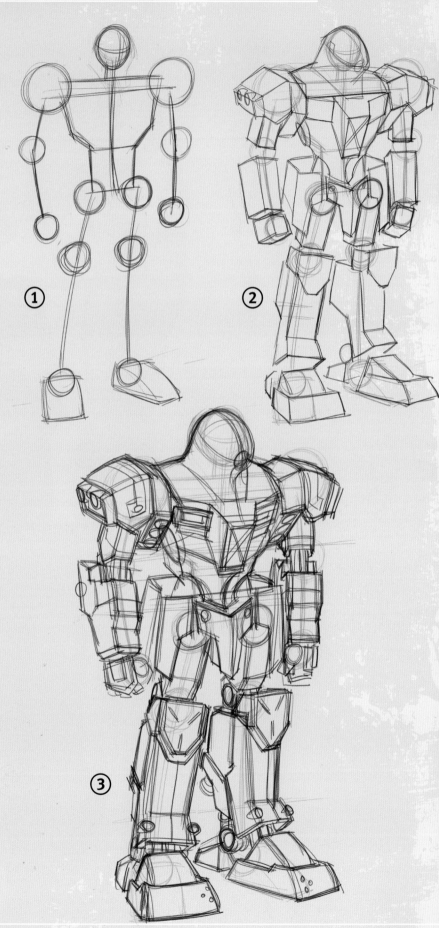

① ② ③

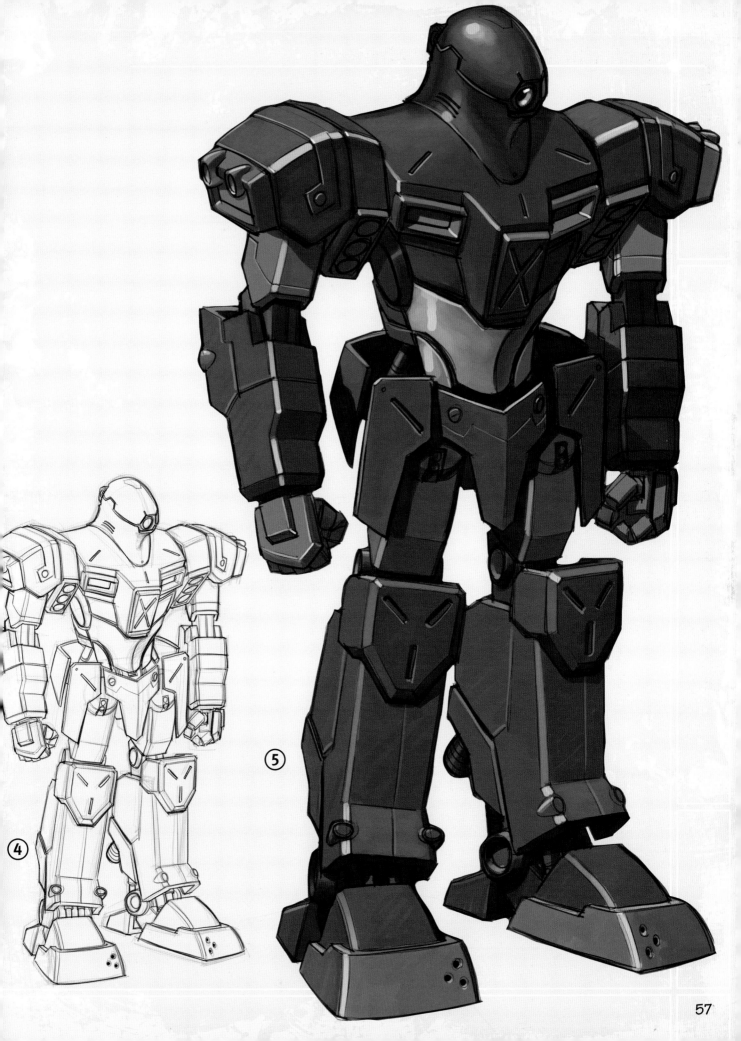

④

⑤

HUMANOID ROBOT ONE: BIRD'S-EYE VIEW

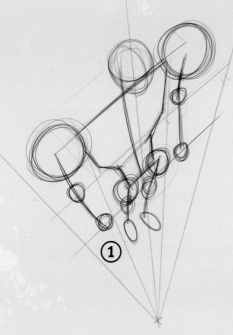

①

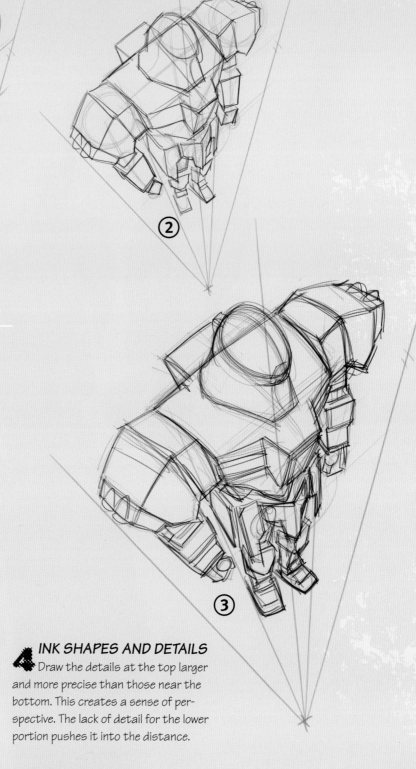

②

③

1 CREATE SKELETAL STRUCTURE

This view requires the top of the robot to be much larger than the bottom. Draw perspective lines that recede to a vanishing point below the robot's feet. Draw the skeletal structure, making sure that the lengths of the arms, legs and chest are proportional to one another.

2 ADD BASIC SHAPES

Use the perspective lines to rough in the basic shapes. If extended, all vertical lines should recede to the vanishing point below. Emphasize the broadness of the shoulders for drama. Don't be afraid to exaggerate.

3 DRAW ROUGH DETAILS

This view creates different opportunities for detail. Use the perspective employed in the basic shapes to add details to the shapes. Use your imagination, but make sure to stay consistent with the details you've outlined in the previous demos if you want to draw the same robot.

4 INK SHAPES AND DETAILS

Draw the details at the top larger and more precise than those near the bottom. This creates a sense of perspective. The lack of detail for the lower portion pushes it into the distance.

5 ADD COLOR

See page 30 for methods on how to color your robot.

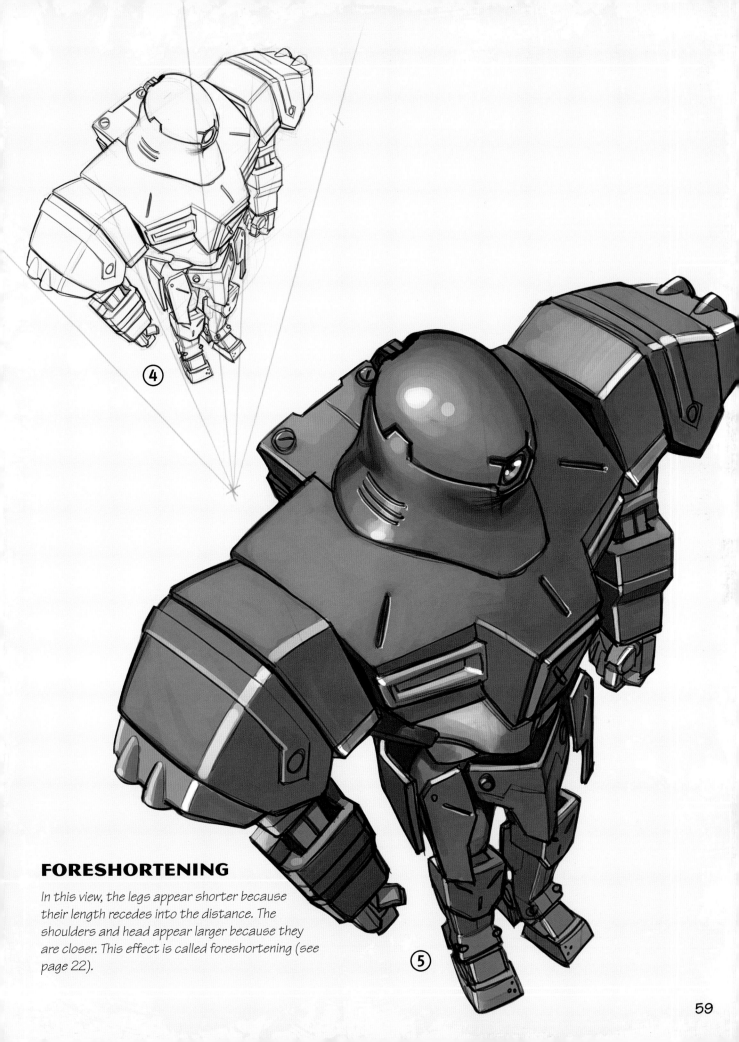

④

FORESHORTENING

In this view, the legs appear shorter because their length recedes into the distance. The shoulders and head appear larger because they are closer. This effect is called foreshortening (see page 22).

⑤

HUMANOID ROBOT ONE: WORM'S-EYE VIEW

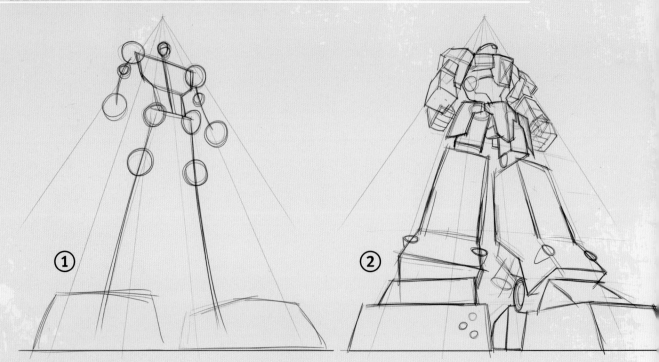

① ②

1 CREATE SKELETAL STRUCTURE

This perspective emphasizes the robot's height. The features at the base of the robot will be largest. Place the vanishing point some distance above the robot's head and draw your perspective guidelines. Draw the skeletal structure. Keep it proportional by using the joints as guides. If something doesn't look right, erase and try again.

2 ADD BASIC SHAPES

Use the perspective guidelines to rough in the basic shapes. All vertical lines should recede to the vanishing point above the robot if extended. Emphasize the shapes at the bottom. The details should be clearer, so allow ample white space. Exaggerate the size difference between top and bottom. Don't hold back or the drawing may be static. If you have to choose, be a little wrong, but be dramatic.

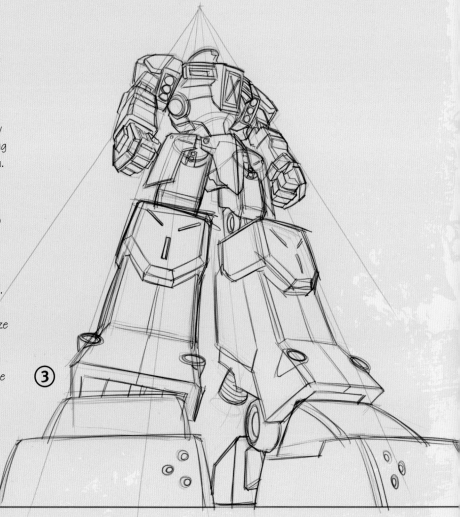

③

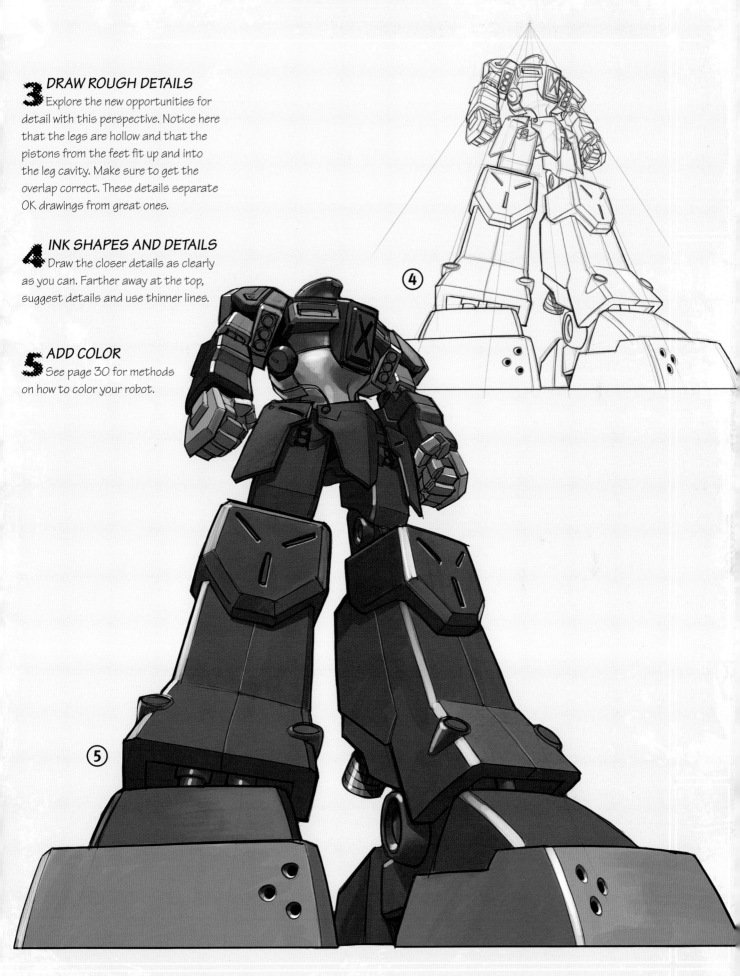

3 DRAW ROUGH DETAILS
Explore the new opportunities for detail with this perspective. Notice here that the legs are hollow and that the pistons from the feet fit up and into the leg cavity. Make sure to get the overlap correct. These details separate OK drawings from great ones.

4 INK SHAPES AND DETAILS
Draw the closer details as clearly as you can. Farther away at the top, suggest details and use thinner lines.

5 ADD COLOR
See page 30 for methods on how to color your robot.

④

⑤

HUMANOID ROBOT ONE: BATTLE POSE

1 CREATE SKELETAL STRUCTURE
Draw the skeletal structure of the robot in battle pose. Raising one leg and extending one fist is not enough. Capture the movement with a twisted torso. Plan how the joints and limbs will line up. Make sure your parts are proportional and appear to move together.

2 ADD BASIC SHAPES
Draw the basic shapes of the robot. Build on the skeletal structure to give shape to the limbs and mass to the body. Keep in mind the rotation or swing of the joints when drawing them. All parts should look like they can move easily on the joint, especially in battle poses.

3 DRAW ROUGH DETAILS
Add rough details to the boxes. Here, the laserlike gun on the top of the robot's right wrist adds drama to the scene.

4 INK SHAPES AND DETAILS
Outline the drawing in ink. Use thick lines for large shapes. Use thin lines for details and implied texture.

5 ADD COLOR
See page 30 for methods on how to color your robot.

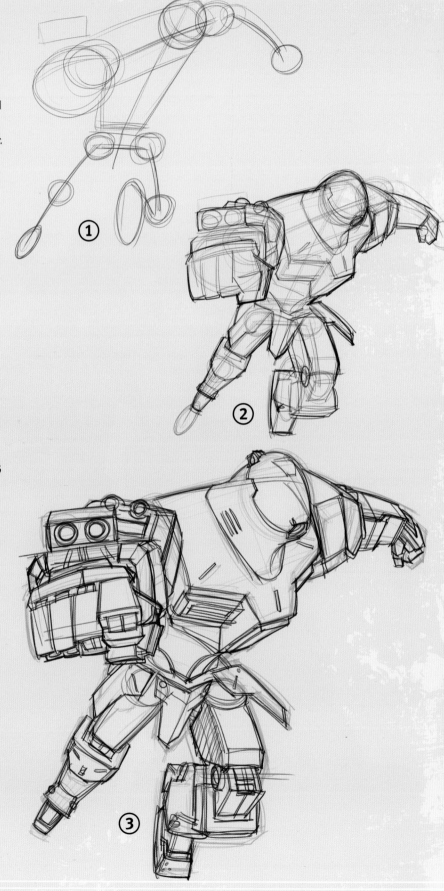

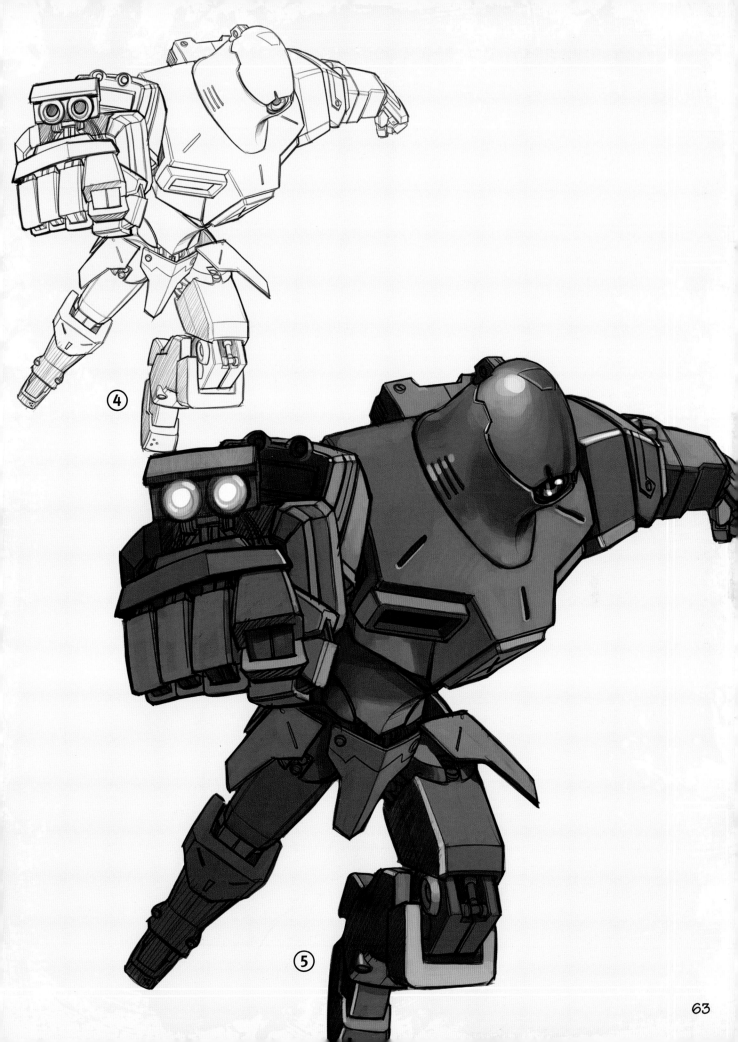

④

⑤

HUMANOID ROBOT TWO: FRONT VIEW

This robot will be a more exaggerated human form. The shoulders and feet give it an imposing and dramatic profile.

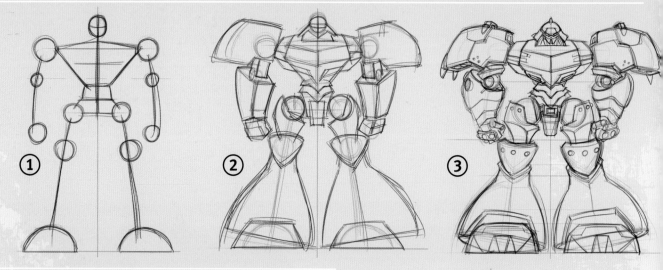

① ② ③

1 CREATE SKELETAL STRUCTURE
Draw the foundation with skeletal structures. Make the shoulder width broad. Match this width by drawing larger feet with a wider stance.

2 ADD BASIC SHAPES
Emphasize the proportions you outlined in step 1. Use your basic shapes to make the shoulders and feet impactful. Showcase their mass. Notice the forearm shapes here. They taper toward the wrist like a human forearm, but the taper is exaggerated. See also how the feet are inside of and surrounded by the legs.

3 DRAW ROUGH DETAILS
Take advantage of the larger shapes to develop a higher level of surface detail. Suggest uses for the shapes. The ridges on the forearm here suggest that they bend over each other like a wrist. These ridges also appear in the abdominal region, suggesting flexibility similar to the wrist.

4 INK SHAPES AND DETAILS
Clarify your details and shapes with ink. Notice here how the overlapping shapes of the elbow and abdominal area are applied to the fingers, especially the thumb. Use shadow. Keep your overlaps clear and precise. Overlapping is the main way to suggest space. Be confident and decisive. If a detail doesn't look right, don't ink it. Erase and correct it.

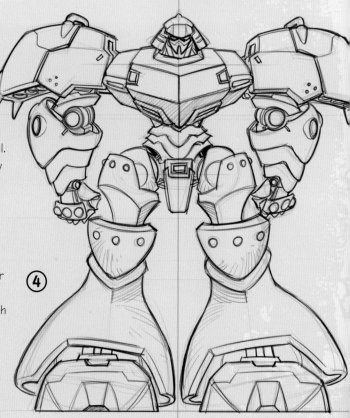

④

REPEAT DETAIL PATTERNS

Find parts that move similarly and give them a similar design. Repeating details will unify the design and make for a well thought-out, more realistic-looking machine.

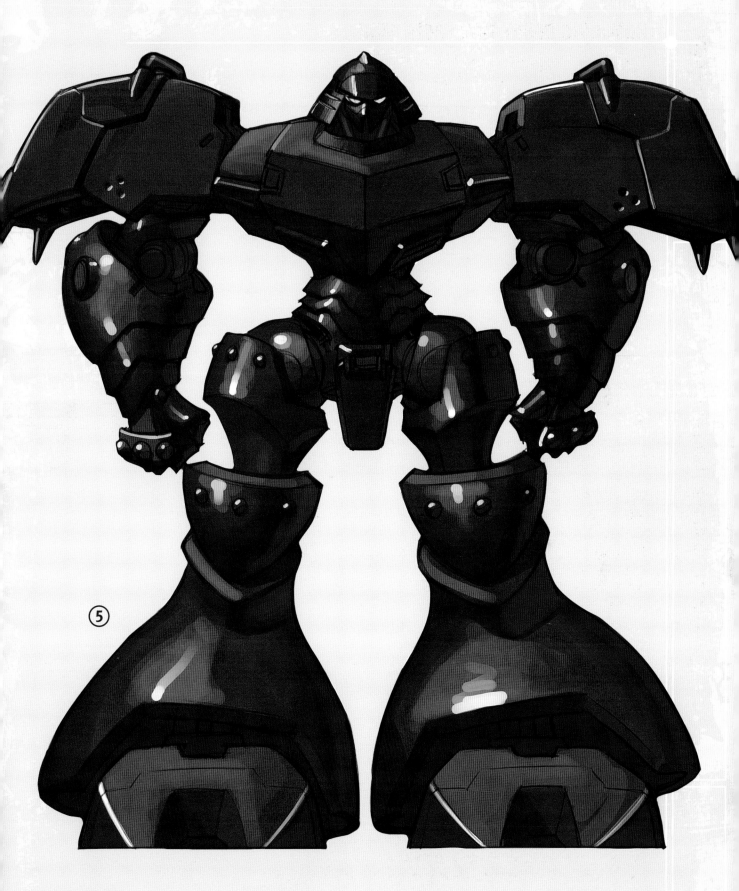

⑤

5 ADD COLOR
See page 30 for methods on how to color your robot.

HUMANOID ROBOT TWO: THREE-QUARTER VIEW

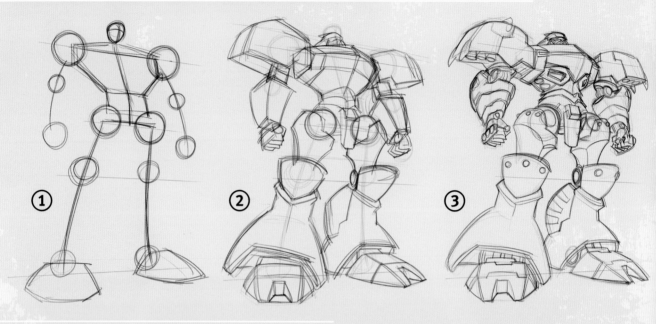

① ② ③

1 CREATE SKELETAL STRUCTURE
Draw the same structure as the previous demo, but turn it to a three-quarter view. Take note which foot, which shoulder, which hand and which knee is placed higher. Use parallel lines to make the height differences consistent.

2 ADD BASIC SHAPES
Take the time to understand how the basic shapes from the previous demos will appear in this view. Notice here how the outside edge of the shoulder is visible only on the left, as with the forearm and leg. Keep the height differences consistent from step 1. Take your time, erasing and redrawing as necessary.

3 DRAW ROUGH DETAILS
Add details to the existing shapes, giving them form and volume while embellishing their surface features. The hands and knees are places to explore greater detail. Lightly draw the complete circular joint to ensure an accurate shape when only a small part is revealed.

4 INK SHAPES AND DETAILS
Complete the details from step 3 and ink the drawing. Use thick, dark lines to emphasize major shapes. Use thinner lines for small details. Be confident with your lines where shapes overlap, even in the smallest details, like the fingers and feet.

5 ADD COLOR
See page 30 for methods on how to color your robot.

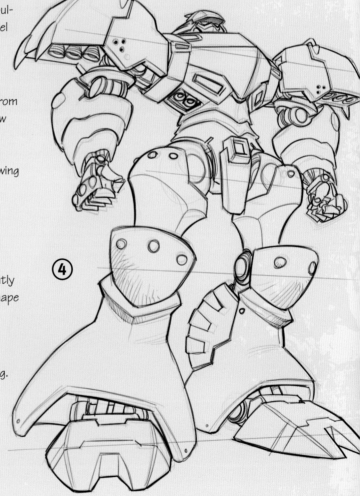

④

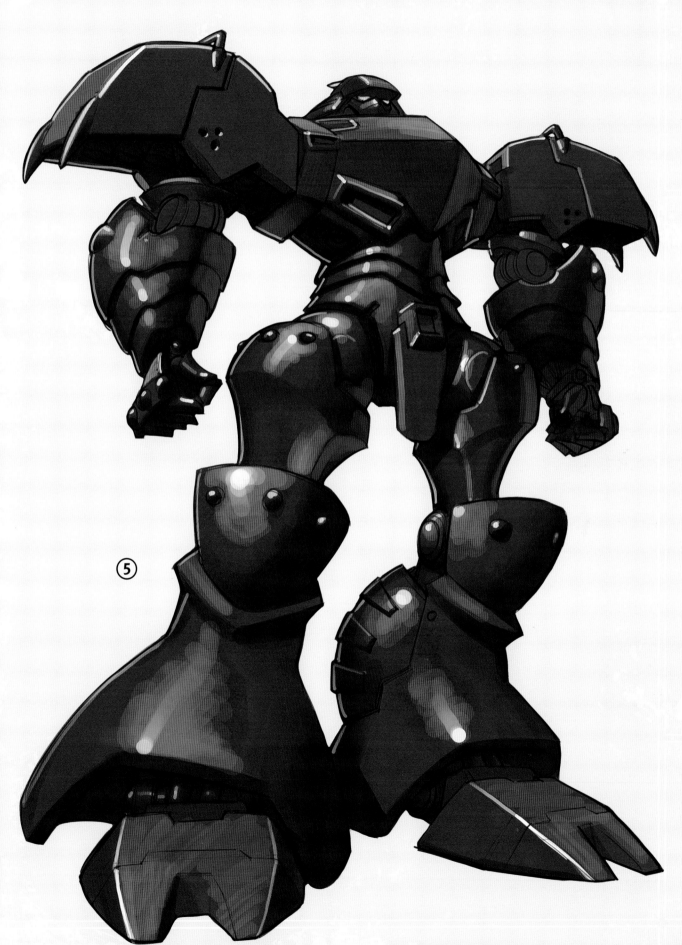

⑤

HUMANOID ROBOT TWO: BIRD'S-EYE VIEW

1 CREATE SKELETAL STRUCTURE
Lay out the robot's skeletal structure using simple lines and shapes. Adjust for proper joint placement and limb proportion. Notice that the shoulder and hip lines are at an angle, yet parallel. The viewpoint here is directly above the robot's left shoulder.

2 ADD BASIC SHAPES
Build upon the skeletal lines to draw the shapes of the body. Visualize how these shapes appear at different angles. Use the previous demos for reference. Use the vanishing point to help you draw the shapes in perspective. Draw shapes through overlaps to ensure proper proportion and placement. Notice here how the elbow joint is visible underneath the large shoulder pad to the right.

3 DRAW ROUGH DETAILS
Add surface details and break the basic shapes down further to indicate potential movement. Remember, large shapes need joints. A robot cannot function as a mass of blocks. For example, the shoulder joint here is made visible and smaller than the shoulder mass as the armor recedes slightly away from the body.

4 INK SHAPES AND DETAILS
Finish by inking the major structures and sharpening the details you wish to emphasize. Here, the three holes on the front of the shoulder armor indicate that the armor has mass and is thick; we see the bottom edge of the holes on the shoulder to the right, and the left side of the holes on the shoulder to the left.

5 ADD COLOR
See page 30 for methods on how to color your robot.

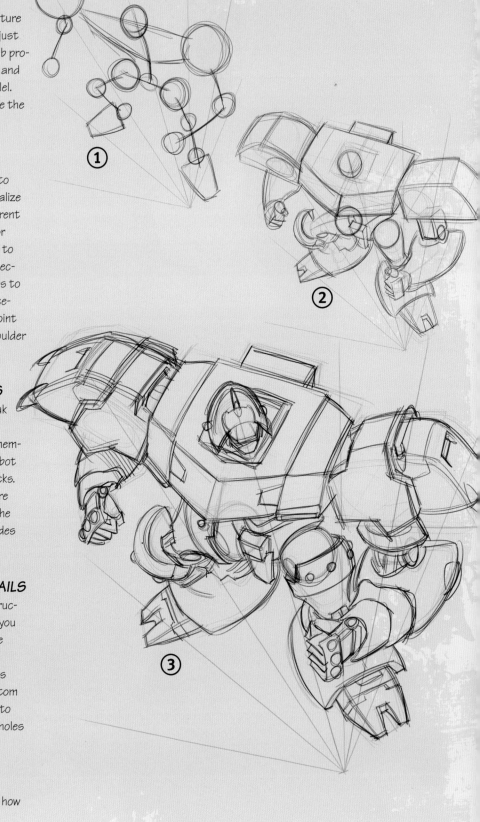

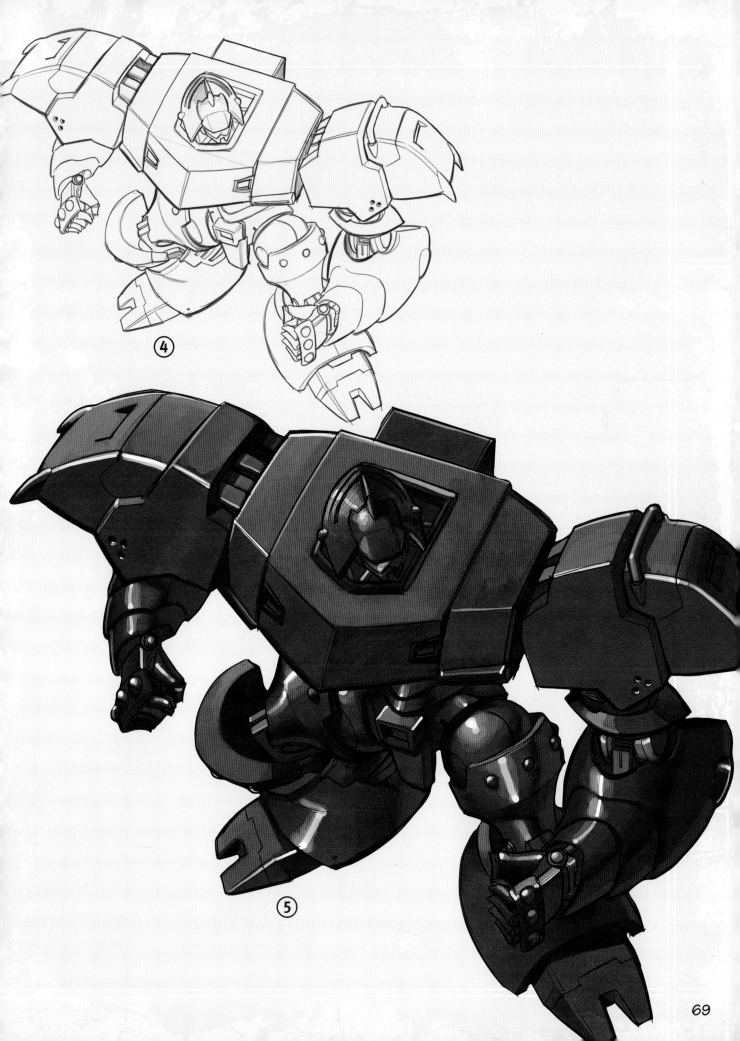

④

⑤

HUMANOID ROBOT TWO: WORM'S-EYE VIEW

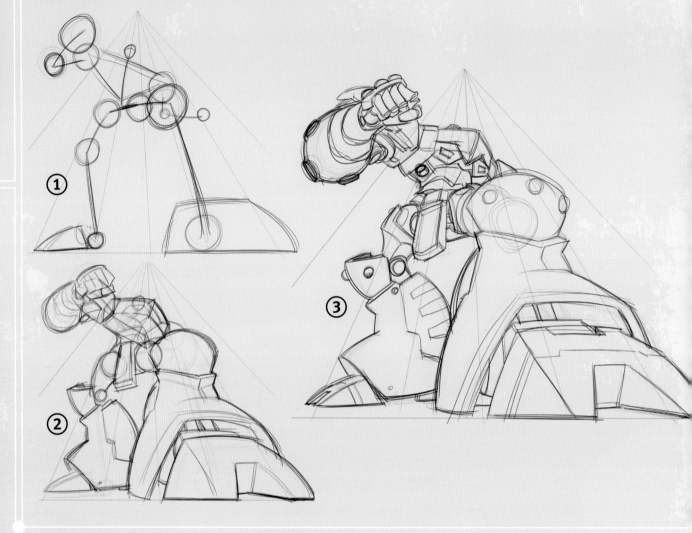

1 CREATE SKELETAL STRUCTURE
This view emphasizes the robot's height. Plan and draw the joints and limbs. This time, the bottom features will appear much larger than the head and shoulders. This pose puts one foot forward and twists the body, so the shoulder and hip lines are at different angles.

2 ADD BASIC SHAPES
Build up the lines into shapes, keeping the angles of the upper body and legs correct. Showcase the legs and feet. Take time to draw the mechanics of the foot attachment correctly to show that the parts travel upward and inside the leg. Use your own hand as a reference for drawing the large, looming fist.

3 DRAW ROUGH DETAILS
Add details to the shapes. Notice how packed the details on the upper body appear compared to the legs. This helps emphasize the viewpoint that the upper body is far above. Adding lines following the shape of the foot makes it appear more mechanical and less "hoof-like." The slightest lines can make the difference.

4 INK SHAPES AND DETAILS
Ink the major structures and refine the details. The thick, black ink line around the front leg makes it visually "pop" into the foreground. The thinner, less defined lines of the rear leg help push it into the background. Make good use of the shadows under the front leg. Because it's so large, make sure the leg is drawn accurately.

5 ADD COLOR
See page 30 for methods on how to color your robot.

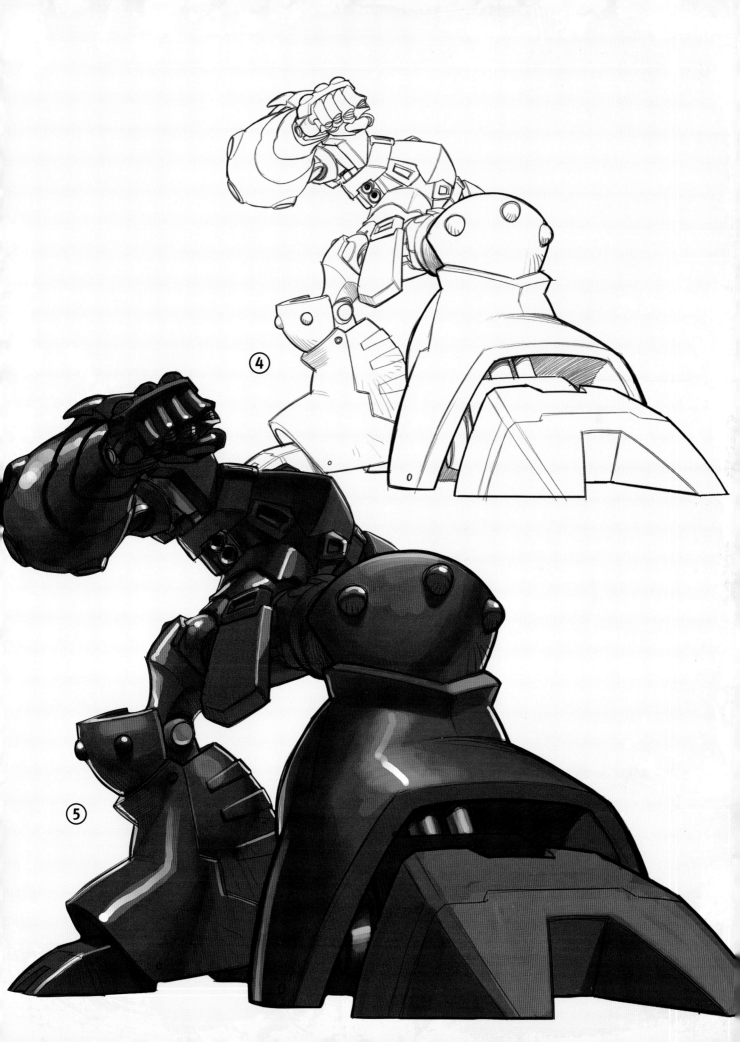

HUMANOID ROBOT TWO: BATTLE POSE

1 CREATE SKELETAL STRUCTURE

Draw the skeletal structure to capture the action of the pose. The leg in front gives the impression of the robot advancing. Make sure the body bends at the joints and nowhere else. The sword should clear the head and tilt slightly toward the viewer.

2 ADD SHAPES AND ROUGH DETAILS

Add the basic shapes of the body, following the pose laid out by the skeletal structure. Carefully form the shapes of the front arm. Be consistent with the shape of the foreleg in the front and side views.

3 FINISH DETAILS AND INK

Follow the shapes of the body to add further detail. Build the mechanics of the foot so that they travel up and into the foreleg casing. Be confident in inking the structures, taking care where they overlap one another. Use thick lines for large shapes and thin lines for details.

4 ADD COLOR

See page 30 for methods on how to color your robot.

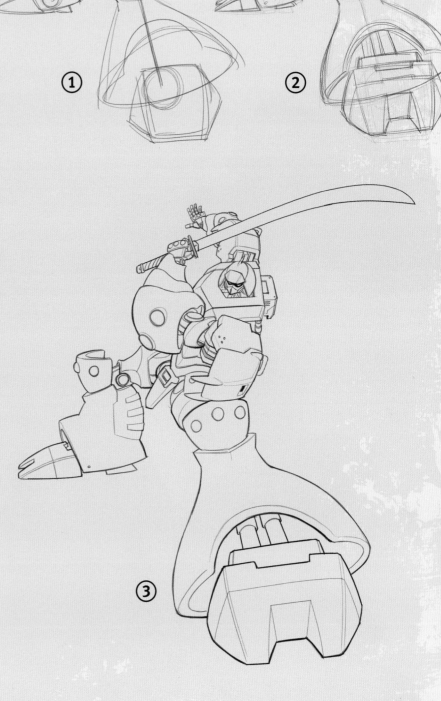

① ② ③

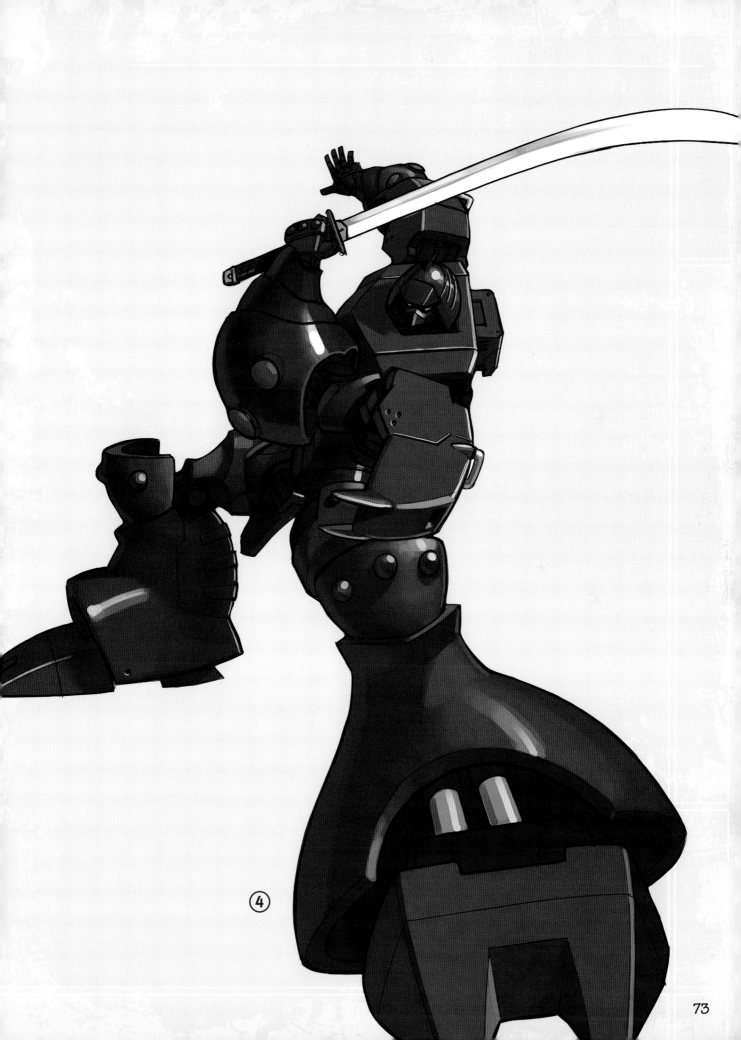

④

WINGED ROBOT: FRONT VIEW

A winged robot should look light enough to fly, and its wings should look strong enough to carry it.

1 CREATE SKELETAL STRUCTURE

Draw your skeletal structure with correct proportions in mind. Include the wing shapes. Decide how big they should be. As always, use the joints as reference points. Use long, straight strokes, and keep the strokes light.

2 ADD BASIC SHAPES

Draw the basic shapes that make up the robot. Separate the torso into chest, ribs, abdominals and hips to express each part through different shapes. The wings should have a joint to allow them to move.

3 DRAW ROUGH DETAILS

Add details to the basic shapes by breaking them into more shapes or adding lines to their surfaces. You can also experiment with exaggerrating small features to help create detail. For example, flare out the lower legs for a wider calf, and use ridge marks on the abdominal region and on the upper thighs.

4 FINISH DETAILS AND INK

Go over the drawing with ink and refine the details. Use shadows where appropriate. This robot is particulary busy. Notice the impactful chest; the diagonal lines from each corner make it appear to jut toward the viewer. Keep the wings simple.

5 ADD COLOR

See page 30 for methods on how to color your robot.

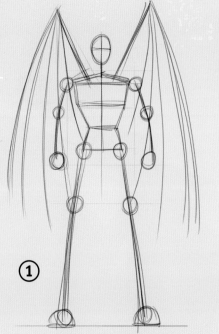

①

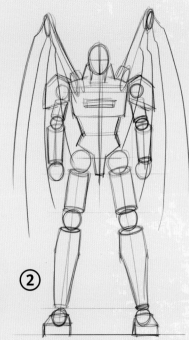

②

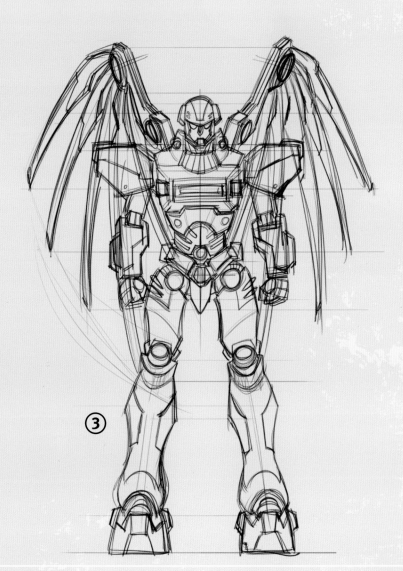

③

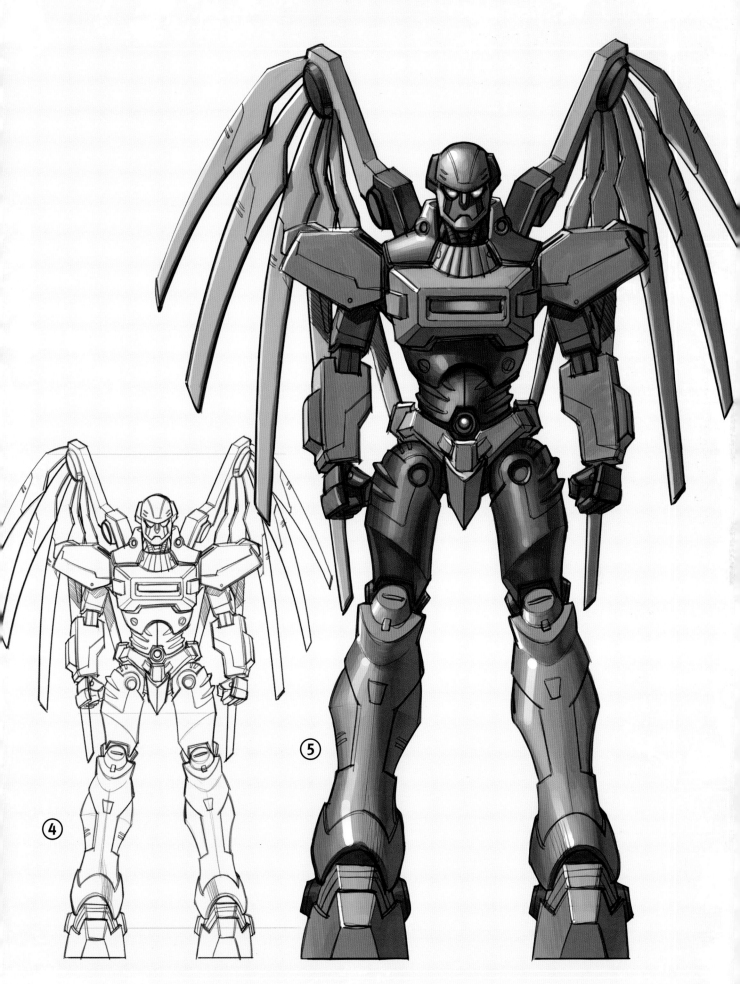

④

⑤

WINGED ROBOT: THREE-QUARTER VIEW

1 CREATE SKELETAL STRUCTURE

Capture the sweep of the wing structure in the initial drawing. Balance the figure by aligning the ankle, knee, hip, elbow, shoulder and wing joints.

2 ADD BASIC SHAPES

Use the same lines to help block in the basic shapes. The front leg appears larger than the back leg. Notice the dramatic thrust of the chest now that the body is turned.

3 DRAW ROUGH DETAILS

Add details to the basic shapes. Give them dimensionality by showing the correct sides in this view. For example, much of the left arm and leg detail is hidden from the viewer. Add more detail to the wings and wing joints.

4 FINISH DETAILS AND INK

Use bolder lines to give the nearest leg more impact. Notice how the details of the chest follow the angles of the underlying chest shape. Dividing the wing "feathers" with a simple line makes them look more metallic and robotic.

5 ADD COLOR

See page 30 for methods on how to color your robot.

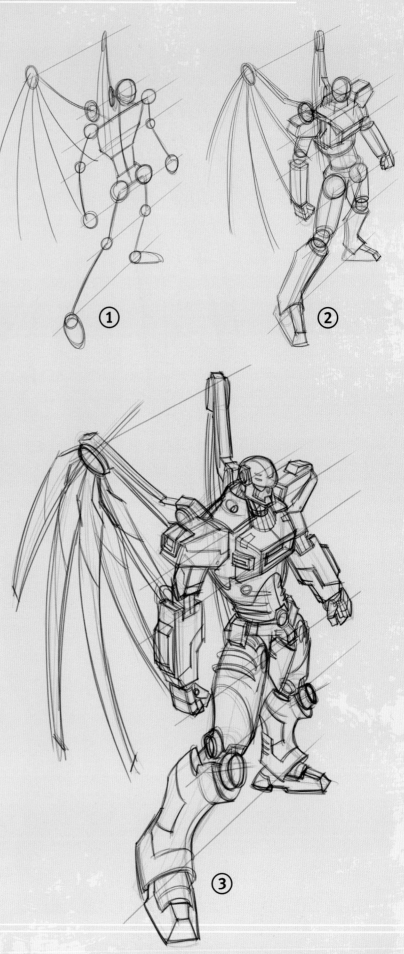

①

②

③

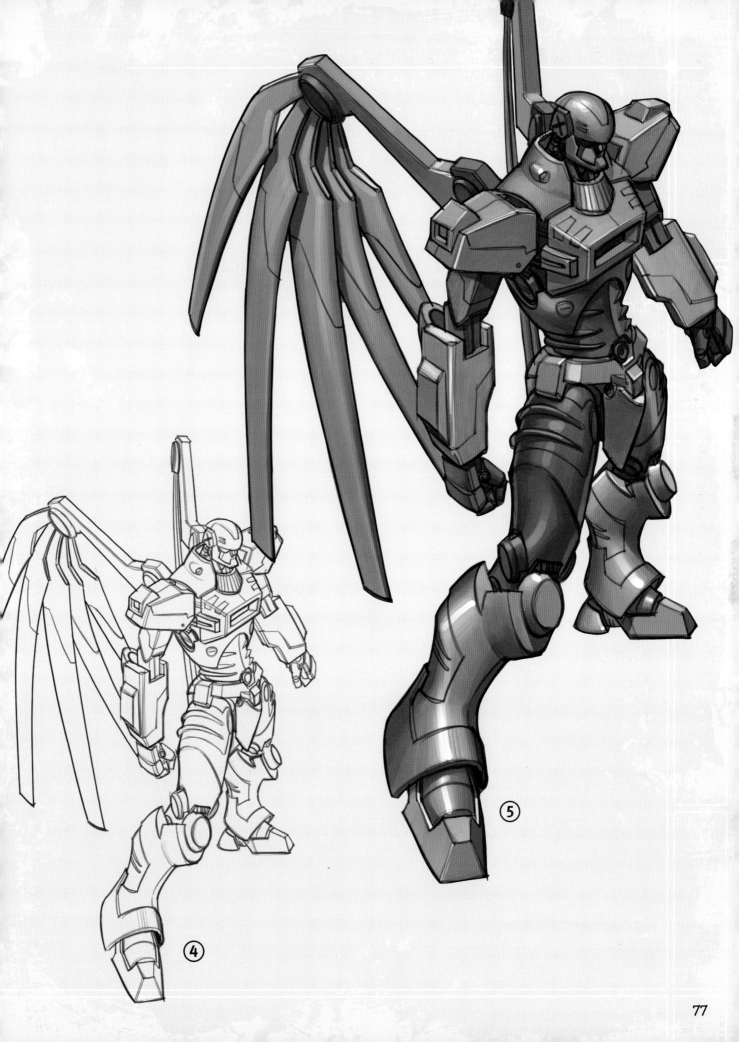

④

⑤

WINGED ROBOT: BIRD'S-EYE VIEW

1 CREATE SKELETAL STRUCTURE

In this view, draw perspective lines converging to a vanishing point below the robot. Draw the basic bone structure using these lines as guides. Show the wings spread and the shoulders and arms as the largest shapes on the body. The left leg is extended here to balance with the wings.

2 ADD BASIC SHAPES

Draw the basic shapes, building on the skeletal structure. Make sure body shapes attached to a joint allow for movement. Notice here how the chest shape juts forward almost a full head length.

3 DRAW ROUGH DETAILS

Add details to the basic shapes and refine their edges. Notice how the detail is spread evenly across the body. The legs only appear more detailed because they are foreshortened in this view. Use a square shape for the top of the hand—a common feature of robots.

4 FINISH DETAILS AND INK

Finish the drawing by following the details established in step 3. Outline the major shapes with a thick line. Go over the details with a thin line.

5 ADD COLOR

See page 30 for methods on how to color your robot.

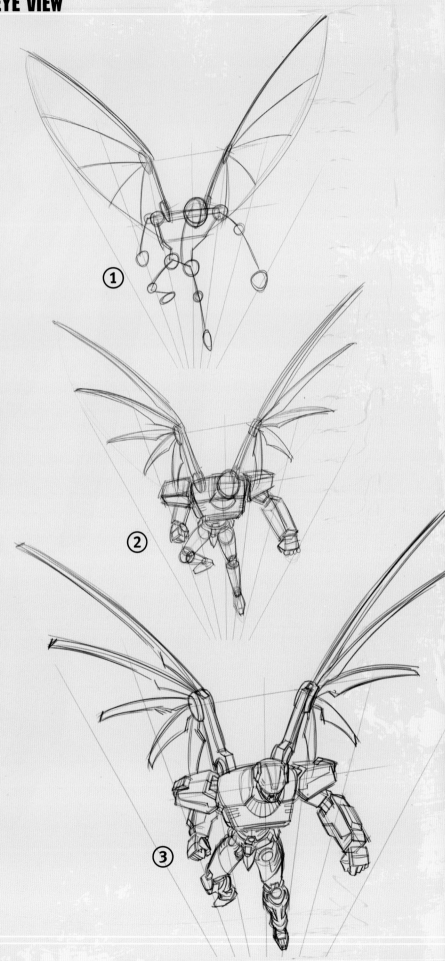

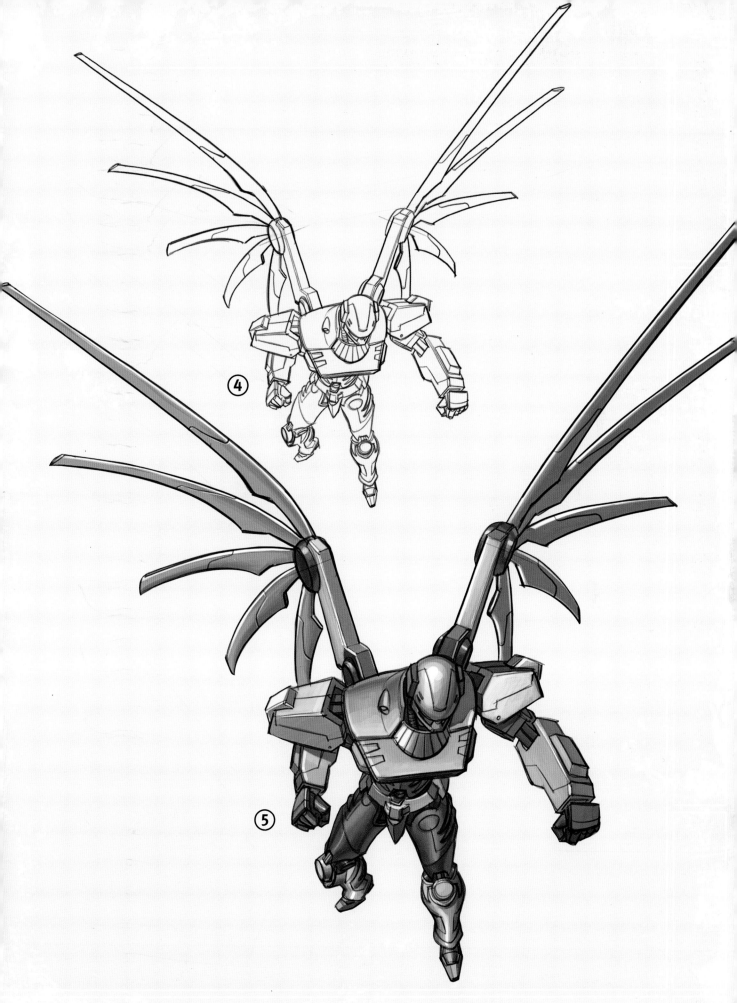

④

⑤

WINGED ROBOT: WORM'S-EYE VIEW

①

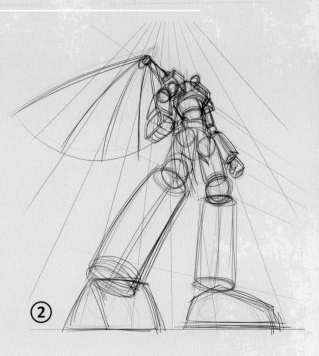

②

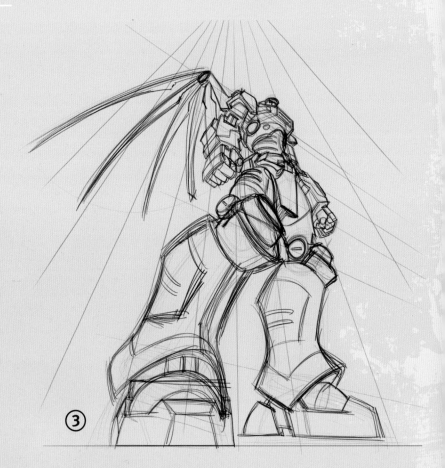

③

1 CREATE SKELETAL STRUCTURE

Draw perspective lines converging toward a vanishing point above the robot's head. Again, use parallel lines to align the joints. The robot's right foot and leg will be the most impactful shape in this view. Start the wings as a simple fan shape.

2 ADD BASIC SHAPES

Build shapes on the skeletal structure. The shapes will be the starting point for the details to come. Make sure each limb is turned to express the robot's stance. The shapes will get smaller as the robot's body moves up and farther away in this view. Notice that the fists appear larger than the head.

3 DRAW ROUGH DETAILS

Add the details and shapes that make a robot. Draw multiple circular knee joint shapes and leg casings to resemble clothing. Far away at the top, rough in the details of the chest, arms and head. Give each of the wing "feathers" their shape.

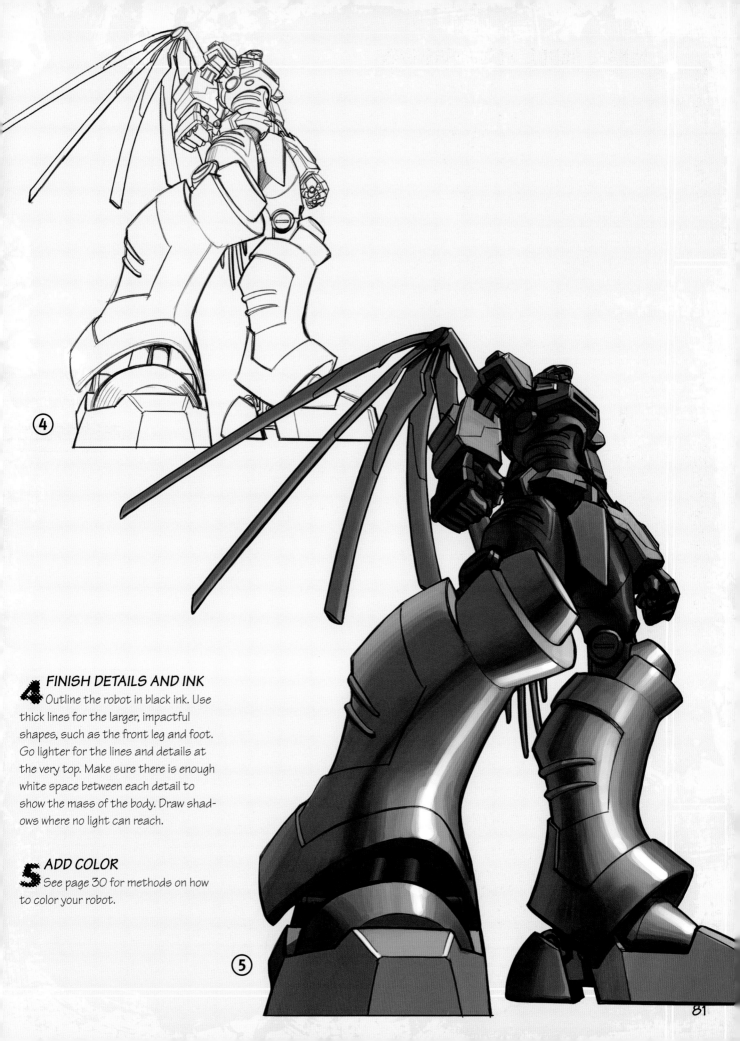

④

4 FINISH DETAILS AND INK
Outline the robot in black ink. Use thick lines for the larger, impactful shapes, such as the front leg and foot. Go lighter for the lines and details at the very top. Make sure there is enough white space between each detail to show the mass of the body. Draw shadows where no light can reach.

5 ADD COLOR
See page 30 for methods on how to color your robot.

⑤

WINGED ROBOT: BATTLE POSE

1 CREATE SKELETAL STRUCTURE

Drawing the structure of a battle pose is like any other view. Visualize the pose and view you want, and rough in the limbs and joints so that the structure of your robot is proportional. The exaggerated hand is one of the largest shapes in this view, which adds depth. The sweep of the wings adds drama.

2 ADD BASIC SHAPES

Draw the basic shapes the same way as for any pose, following the skeletal structure. Pay special attention to the elbows and knees. The elbow of the left arm here is in line with the shoulder and hand.

3 DRAW ROUGH DETAILS

Add details to the body part shapes. For the fingers, outline the shape of each segment, but remember to allow a gap for movement. Roughly emulate the muscles of your own hand in the robot's hand.

4 FINISH DETAILS AND INK

Finish with ink and outline each shape and detail. Vary your line width. Use thicker lines for larger shapes that appear closer. Be confident in how the shapes are overlapping. Leave enough white space between the ink lines to show the mass of the body.

5 ADD COLOR

See page 30 for methods on how to color your robot.

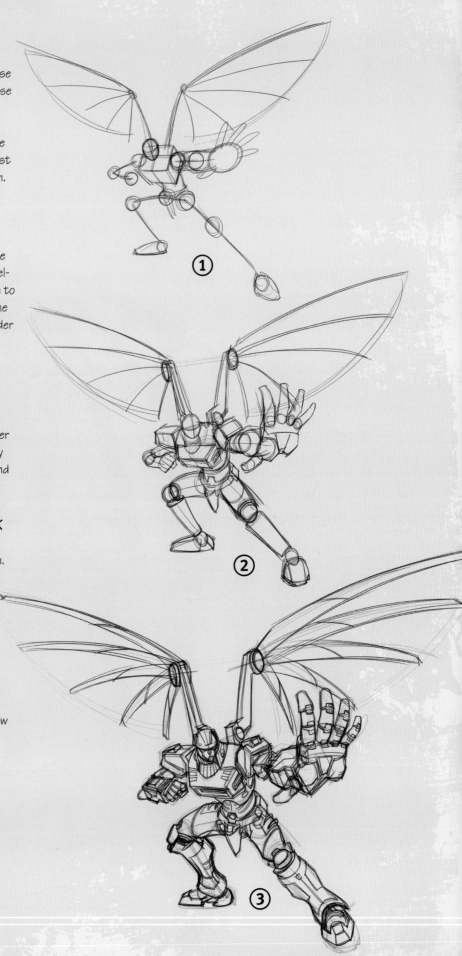

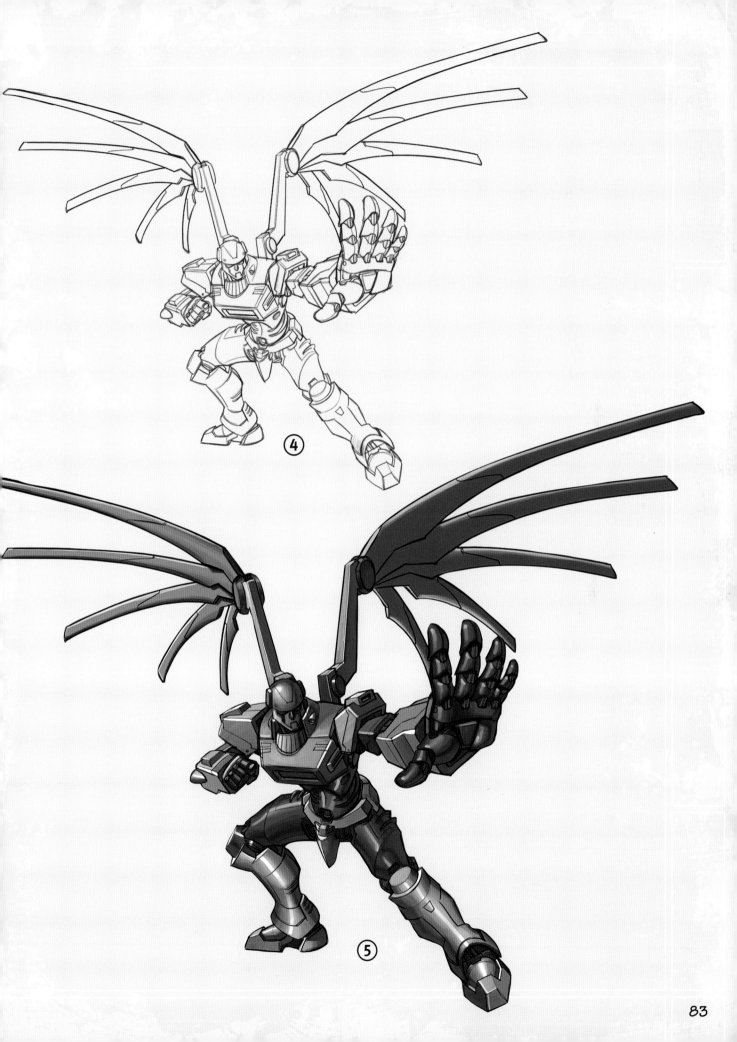

④

⑤

FEMALE ROBOT: FRONT VIEW

A female-looking robot requires feminine proportions; namely, longer legs, wider hips and narrower shoulders and waist.

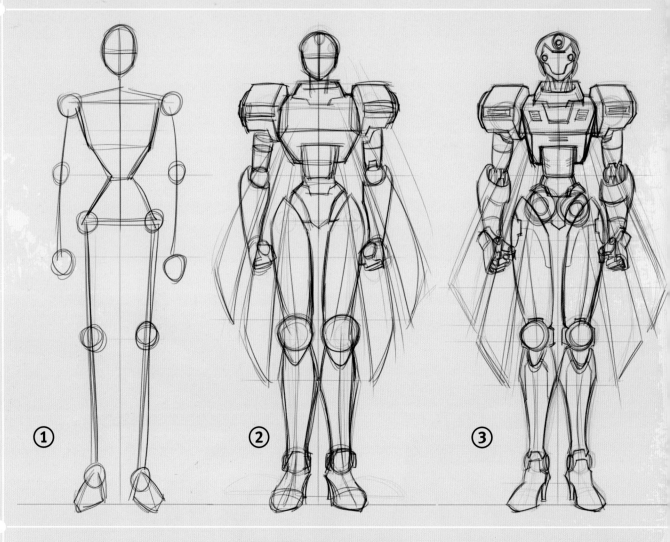

① ② ③

1 CREATE SKELETAL STRUCTURE
Map out the porportions correctly. A female robot will have proportions similar to a female human. Draw the legs longer and the shoulders narrower.

2 ADD BASIC SHAPES
Add curvier, lighter-looking shapes to the skeletal structure. Bow in the legs slightly to emphasize the hip width. Draw the head higher to suggest a longer neck. Remember, most joints bend or rotate in only one direction.

3 DRAW ROUGH DETAILS
Refine the shapes with precise lines. Give them volume by adding additional sides. Add mechanical surface details, keeping in mind, when possible, the purpose of each particular part. Especially with a female robot, do not bunch large block shapes close to one another; separate them with a joint.

4 INK SHAPES AND DETAILS
Complete the details from step 3. Use shadows to show depth. For this robot, keep your surface lines long and smooth. Follow the curves of your shapes to help show the form, keeping the robot feminine.

5 ADD COLOR
See page 30 for methods on how to color your robot.

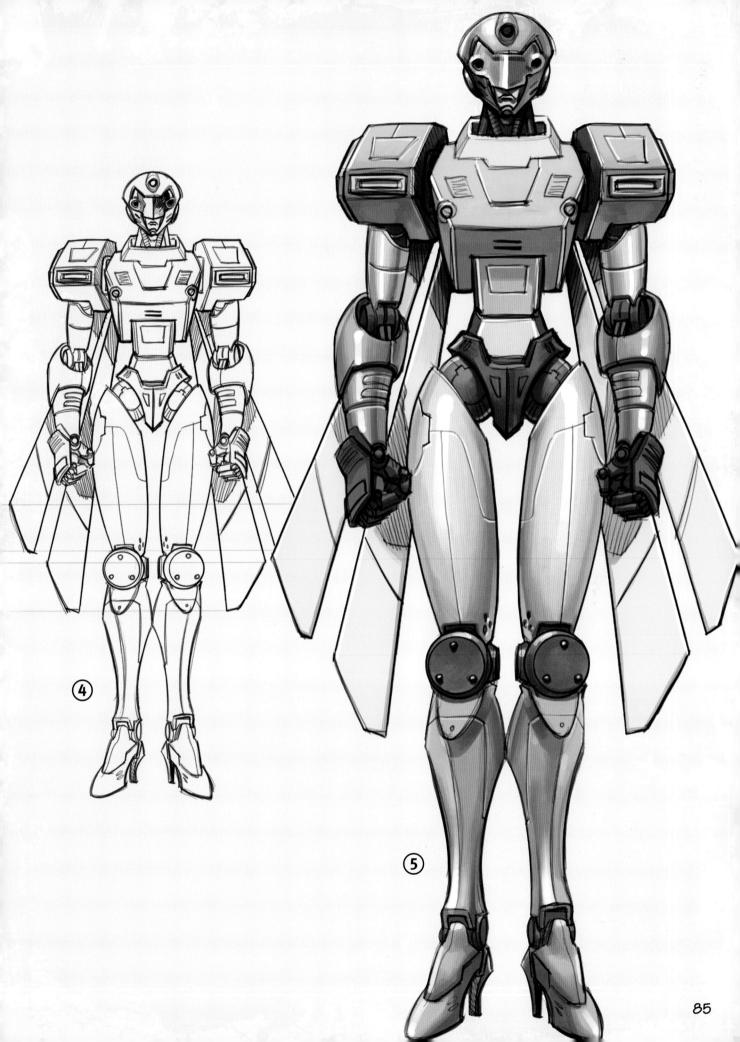

④

⑤

FEMALE ROBOT: THREE-QUARTER VIEW

①

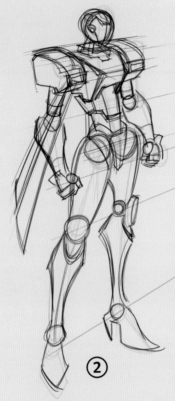

②

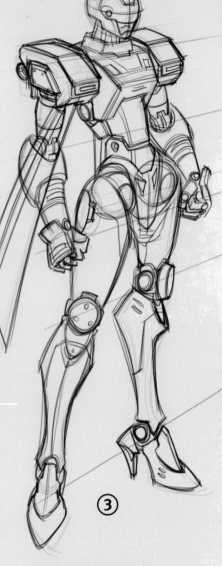

③

1 CREATE SKELETAL STRUCTURE

In this view, the robot's left side is higher. Sketch your skeletal structure using the joints as guides. Use guidelines to place the ankles, knees, hips, elbows and shoulders.

2 ADD BASIC SHAPES

Show only what is visible. Don't be afraid to leave things out completely, like the back of the left leg and wing. Keep your shapes in line with the behavior of the joint attaching them. Curve your shapes to make them more feminine.

3 DRAW ROUGH DETAILS

Break up your basic shapes into more refined shapes. Add surface lines. Focus on areas new to this view, such as the side of the left knee and the robot's right armpit.

4 FINISH DETAILS AND INK

Finish the robot by following the details established in step 3. Add shadows to the places that are covered by other shapes: near the hip, under the shoulder and in the "hole" at the top of the head.

5 ADD COLOR

See page 30 for methods on how to color your robot.

REPEAT SHAPES FOR DETAIL

As a starting point for adding additional shapes for details, mimic the shape surrounding it. Notice the shape on the outside of the robot's right shoulder; its outline matches the outline of the main shoulder.

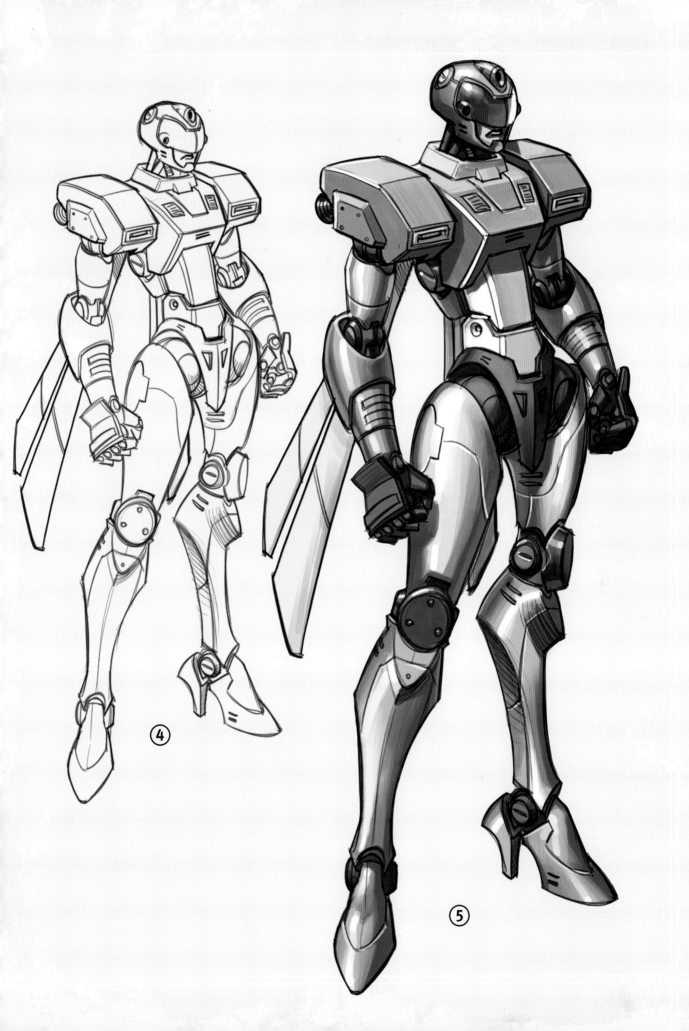

④

⑤

FEMALE ROBOT: BIRD'S-EYE VIEW

1 CREATE SKELETAL STRUCTURE

Draw the skeletal structure and joints. Map out the perspective lines for this view, placing the vanishing point below the robot's feet. Make sure your angles are correct. The hip, chest and shoulder lines are parallel but angled.

2 ADD BASIC SHAPES

This view requires you to account for the wings and emphasize the head and shoulders. Draw the shapes of the joints, keeping in mind their specific range of motion. Use the perspective lines to help draw the shapes of the robot's body.

3 DRAW ROUGH DETAILS

Add details, keeping in mind which parts of the body are newly revealed in this view. Keep the amount of detail consistent across the whole robot. Don't draw more on the top because there is more surface area. Leave white space to show bulk and make the shapes impactful.

4 FINISH DETAILS AND INK

Ink your drawing, taking care to outline the major shapes. Use thicker lines to bring the foreground shapes closer and thinner lines to push the background shapes away. Notice the thick shoulder lines here compared to the lighter lines of the feet.

5 ADD COLOR

See page 30 for methods on how to color your robot.

BE PURPOSEFUL

Everything drawn should appear to serve some purpose. Even if it's decorative, it must work with the operation of the robot's joints and limbs.

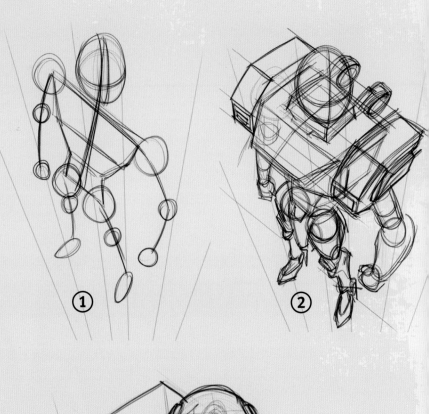

① ②

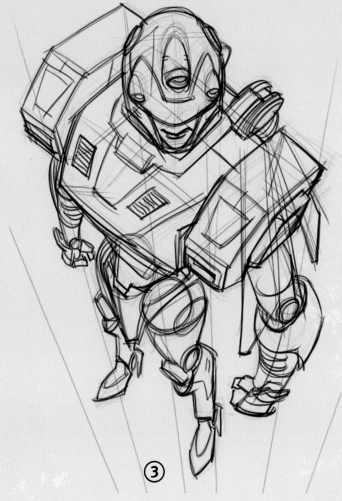

③

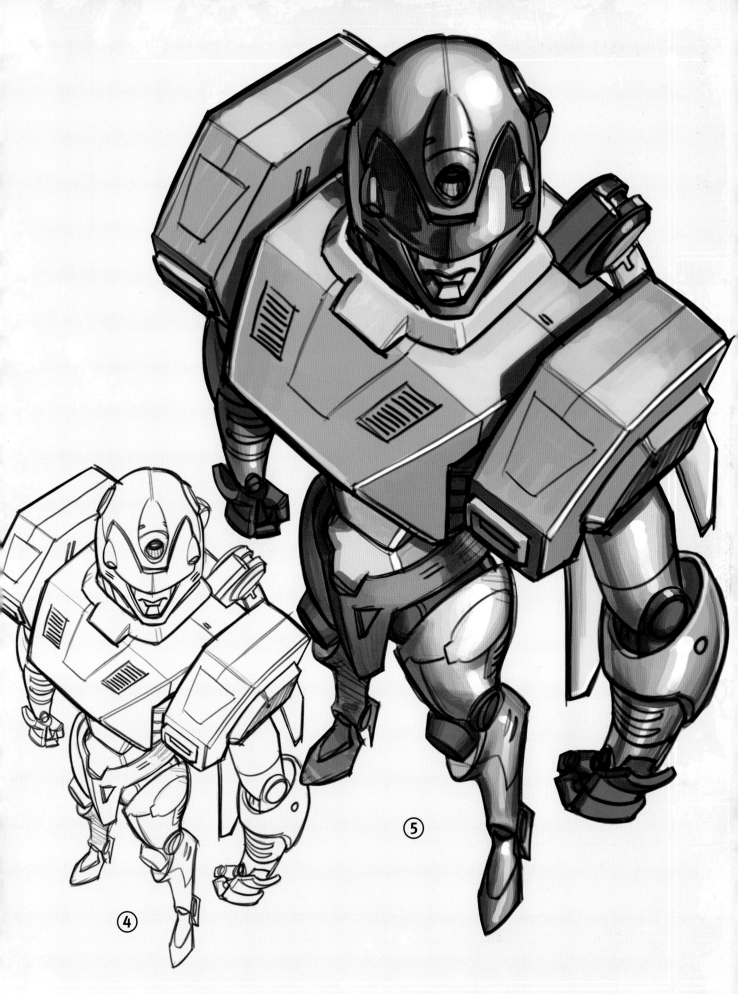

④

⑤

FEMALE ROBOT: WORM'S-EYE VIEW

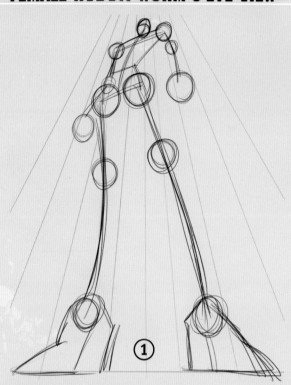

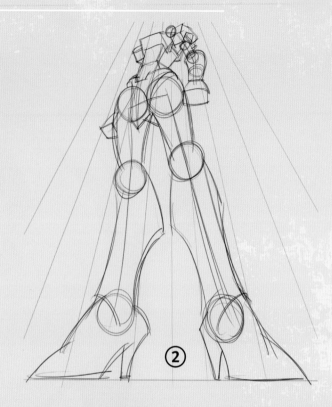

1 CREATE SKELETAL STRUCTURE

This view showcases the robot's height. The upper joints will appear bunched at the top, while the leg joints will be farther apart. Draw the skeletal structure to capture the proper body length. Use the joints as distance markers to gauge proportion.

2 ADD BASIC SHAPES

Draw the mechanical parts as basic shapes, lining them up with their joints. Pay special attention to elbows and knees. Emphasize the length of the legs by drawing these shapes longer than the upper body, which is foreshortened. Notice that the legs take up almost four-fifths of this drawing.

3 DRAW ROUGH DETAILS

Add details to the foreground ankle joint-heel assembly and the bottom of the knee joint. Don't be tempted to overdo the detail on the legs because they appear bigger. Keep it simple. Simple geometric shapes keep the robot machinelike. Suggest the viewable details in the upper body.

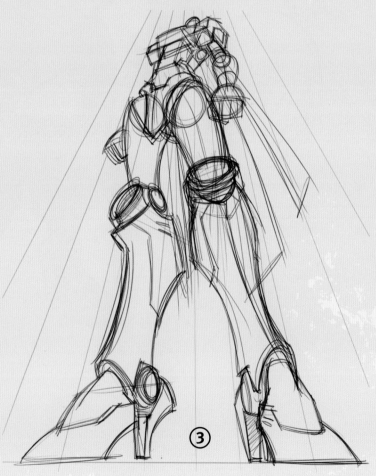

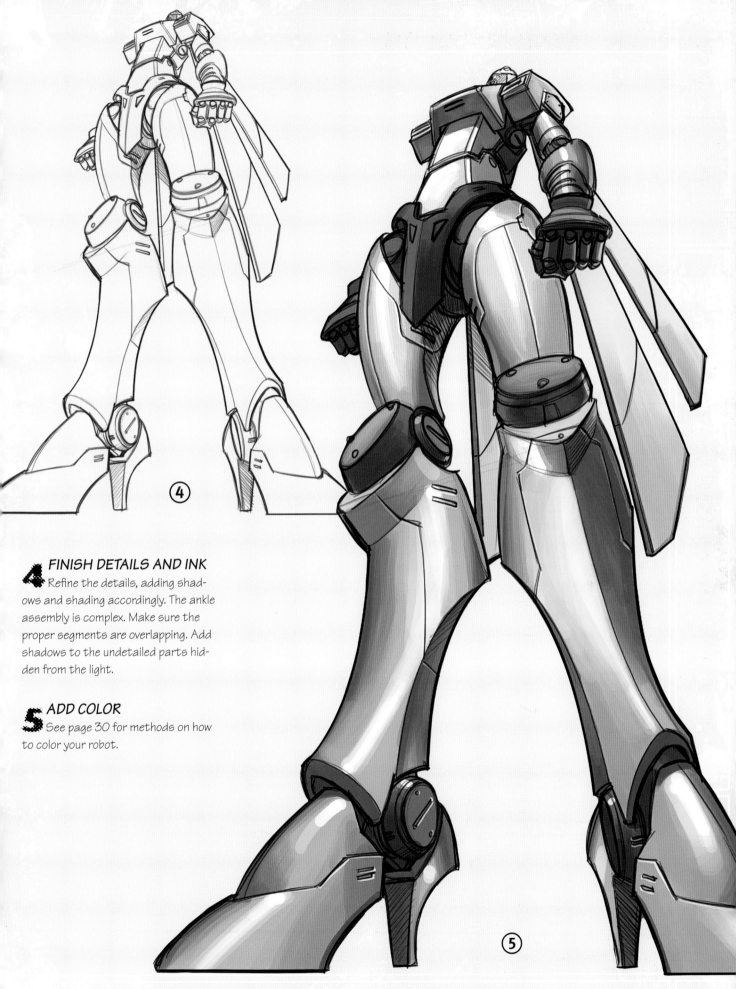

FINISH DETAILS AND INK
Refine the details, adding shadows and shading accordingly. The ankle assembly is complex. Make sure the proper segments are overlapping. Add shadows to the undetailed parts hidden from the light.

ADD COLOR
See page 30 for methods on how to color your robot.

④

⑤

DRAGON ROBOT: SIDE VIEW

A dragon robot has joints and shapes like a human-oid. Treat this side view like a technical drawing.

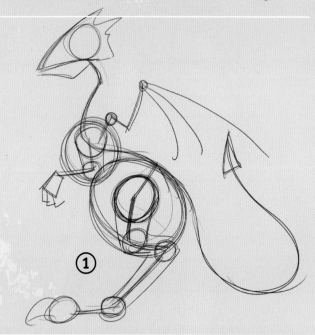

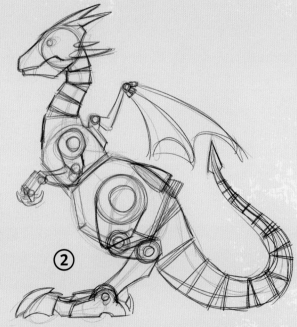

1 CREATE THE SKELETAL STRUCTURE
Use the joints and limbs to work out a structure that is pleasing. Notice that the leg is jointed twice. The dragonlike features should already be apparent.

2 ADD BASIC SHAPES
A dragon robot moves differently than a humanoid robot, so make sure the the joints and shapes interact correctly. Draw the tail and neck as a series of shapes that can move. The leg needs different shapes than a humanoid too. The foot claw is separated into segments. The head is angular.

3 DRAW ROUGH DETAILS
Add detail and refine your rough shapes. Use similar shapes for the neck and tail to show that they move similarly. Use similar shapes for the claws of the hands and feet since they serve a similar purpose. Explore the details of the joints at the hip and shoulder. Examine the curvature of the mouth.

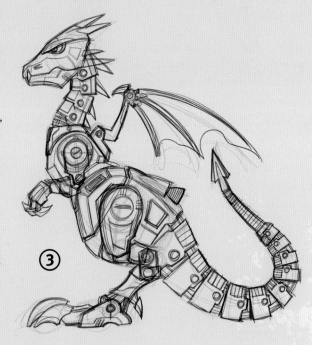

4 FINISH DETAILS AND INK
Outline the larger body shapes with thick ink lines. Use thinner lines for the small body parts and details. Shadows in small sections of the body give the appearance of mechanical holes or nooks. A robot is made from parts; give each part its individual flavor to make the whole robot realistic.

5 ADD COLOR
See page 30 for methods on how to color your robot.

FEATURES OF A DRAGON

Toy with this drawing until you have a creature with dragonlike proportions: large, lizardlike head; long neck and tail; smaller wings and forearms and clawed hands and feet.

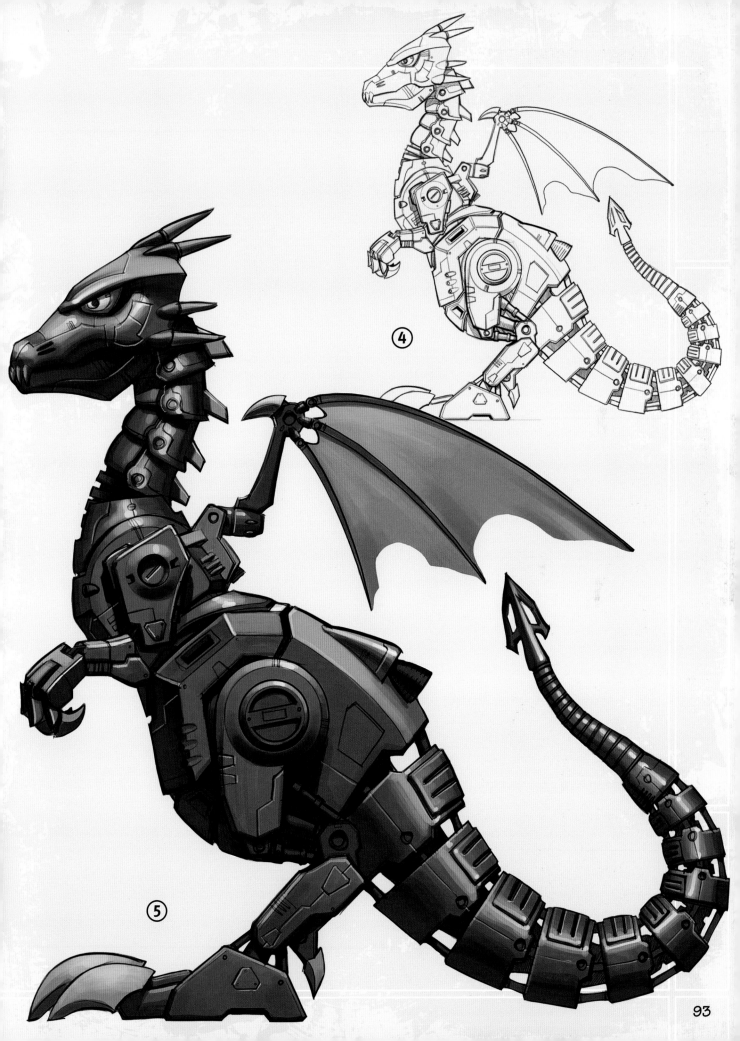

④

⑤

DRAGON ROBOT: THREE-QUARTER VIEW

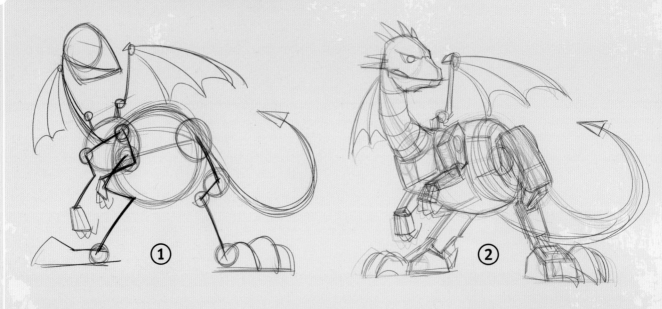

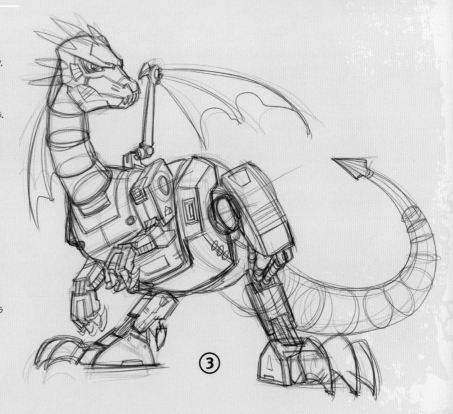

1 CREATE SKELETAL STRUCTURE

Draw the skeletal structure in this view. The angles of the arms, legs, chest and hips are all different. Draw the center body mass and joints as general circles. Make sure they work together with the limbs to make the pose look fluid. The head facing back toward the body balances the figure.

2 ADD BASIC SHAPES

Take your time in this step. Draw the basic shapes from the skeletal structure. Rough in the fingers, feet, mouth, wings and eyes. Every shape will be different. Work carefully on the joints and angle of the facing leg. Remember the motion of a joint as you draw the shapes connected to it.

3 DRAW ROUGH DETAILS

Add details by further refining the basic shapes and adding mechanical elements to the surfaces. Decide where your major shapes will be. Notice here how the roundness of the outside hip is now an angled mechanical piece. Explore the joints of the wings and legs. There is ample room for movement in the lower leg here as its casing recedes from both the knee and ankle.

4 FINISH DETAILS AND INK

Outline the shapes and details. Create shadows by means of complete black or crosshatching to achieve a gray. The shadows under each neck piece emphasize that the neck is indeed a series of individual pieces.

5 ADD COLOR

See page 30 for methods on how to color your robot.

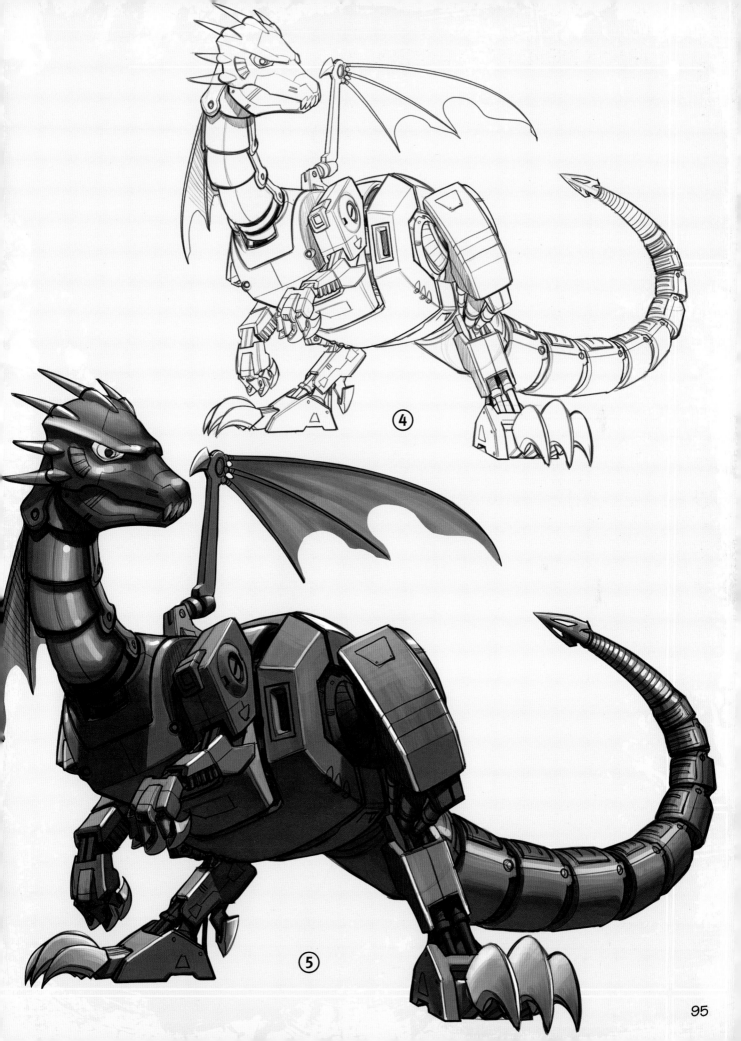

④

⑤

DRAGON ROBOT: BIRD'S-EYE VIEW

1 CREATE SKELETAL STRUCTURE

Start out with the skeletal structure of this view, which looks into the dragon's mouth. Draw the joints and basic body mass. Work until the skeleton is proportional. The wings and neck will be almost directly beneath the viewer. Therefore, their shapes will be greatly foreshortened.

2 ADD BASIC SHAPES

Draw the basic shapes of the robot from the skeletal structure drawn in step 1. Don't be too rigid at this stage. Make sure to capture the sweep of the body by turning your shapes accordingly. The mouth cavity is a series of circles. The head and back form the largest shapes. Notice here how the feet are now far below and drawn smaller to show the distance.

3 DRAW ROUGH DETAILS

Define the edges of your shapes and rough in the details. Pay attention to which shapes overlap others. The neck and tail remain a series of circular shapes strung together, yet the neck is almost completely obscured by the bulk of the head and the foreshortening. Take the time to understand how the shapes drawn in previous views appear in this view. Explore the revealed joints of the jaw.

4 FINISH DETAILS AND INK

Finish the details established in step 3. Go over the lines with ink, varying the line width between thin and thick. Use repeating elements in the tail to separate it from the body mass. Make sure your details allow for joint movement.

5 ADD COLOR

See page 30 for methods on how to color your robot.

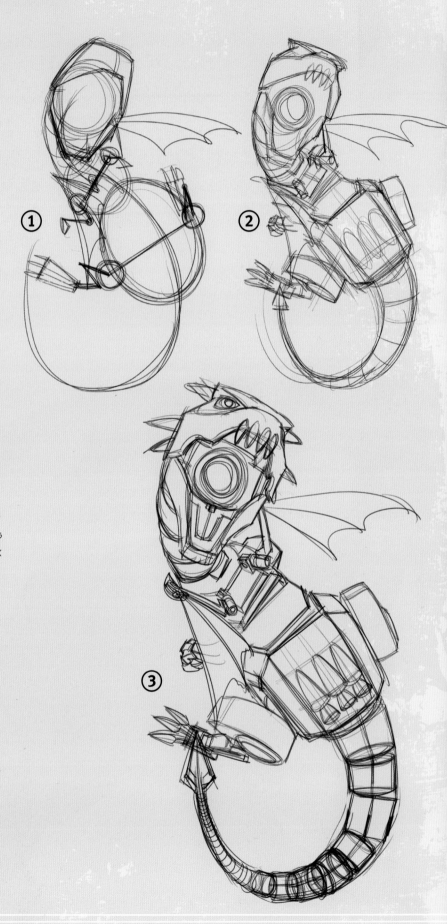

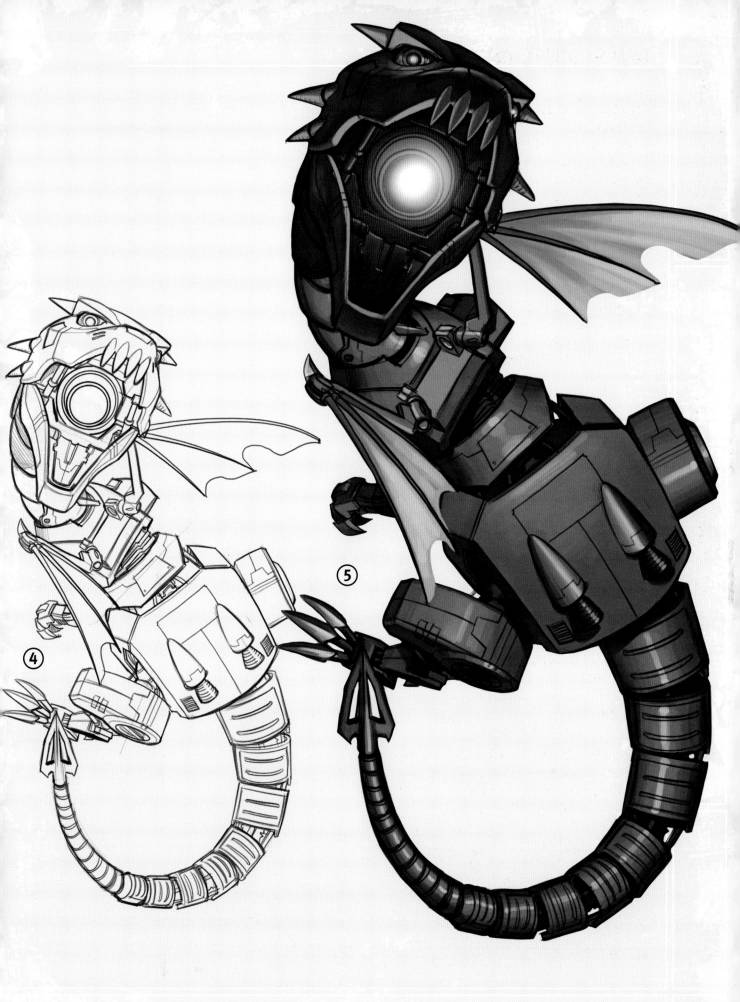

④

⑤

DRAGON ROBOT: WORM'S-EYE VIEW

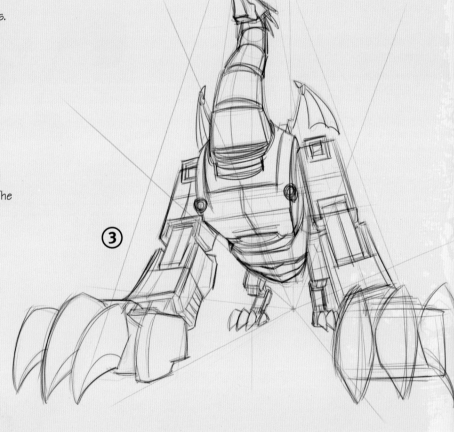

1 CREATE SKELETAL STRUCTURE

Draw the basic skeletal structure of the dragon using the joints as markers. The feet are large and imposing in this view, though at this stage the robot resembles a dog.

2 ADD BASIC SHAPES

Showcase the segments of the front legs and claws. Build the shapes out from the skeletal structure, and carry the bulk of the body back toward the distant hind legs. Add the wings. The robot's left shoulder is higher because that side is closer to the viewer.

3 DRAW ROUGH DETAILS

Perspective lines show us a vanishing point far above and behind the robot. The horizontal lines of the shapes of the robot's body should recede to this point as the shapes move away from the viewer. Use these lines as guides to the details of the legs. Separate the front leg joint from the body casing. Mark out the segments of the neck and the details of the jaw.

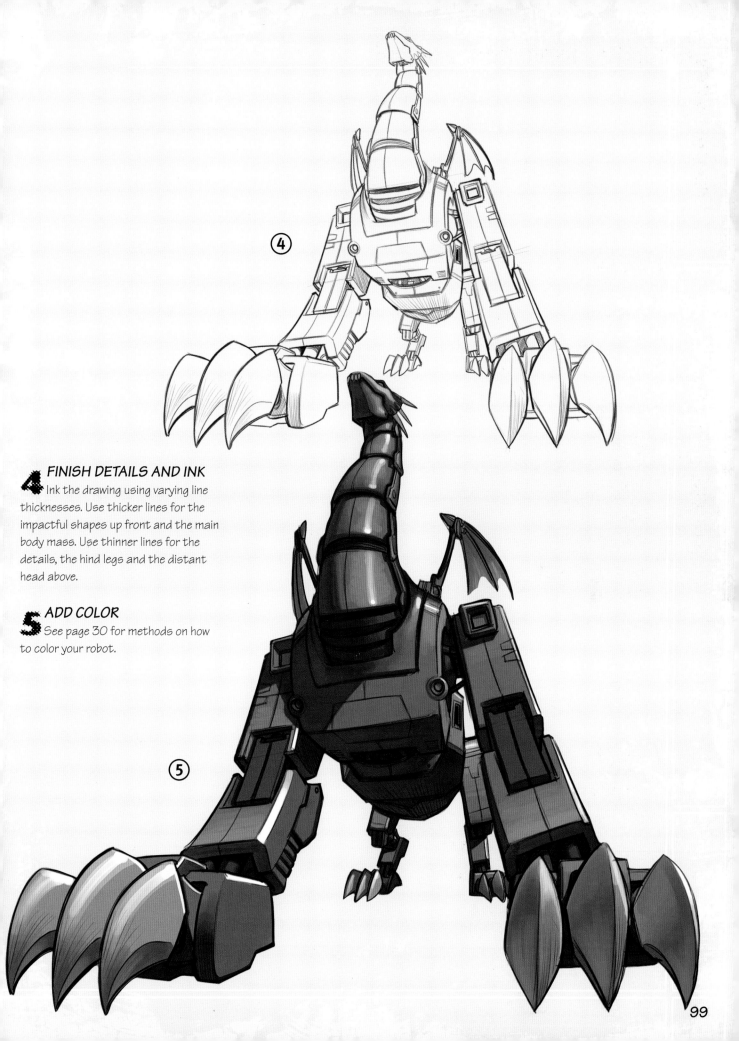

4 FINISH DETAILS AND INK
Ink the drawing using varying line
thicknesses. Use thicker lines for the
impactful shapes up front and the main
body mass. Use thinner lines for the
details, the hind legs and the distant
head above.

5 ADD COLOR
See page 30 for methods on how
to color your robot.

DRAGON ROBOT: BATTLE POSE

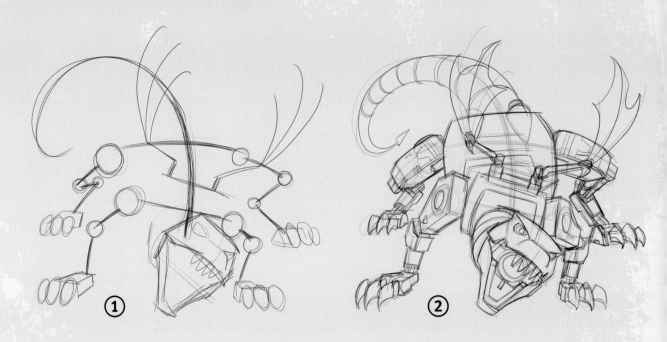

1 CREATE SKELETAL STRUCTURE

Pay special attention to the angle of the hind legs. Draw the hindquarters so that they are visible. The head is down and poised for battle. Rough in the angle and shape of the head.

2 ADD SHAPES AND ROUGH DETAILS

Build the shapes of the body from the skeletal structure. Keep the limbs separated by visible joints. When the joints aren't visible, keep a distance between adjoining forms, such as the hind legs and hip. Notice how the shape behind the head—the torso—is tilted with the head and the bending of the robot's front left leg.

3 FINISH DETAILS AND INK

Ink the major shapes that have outside edges with thick lines. Use thin lines for interior edges, details and shapes farther in the background.

4 ADD COLOR

See page 30 for methods on how to color your robot.

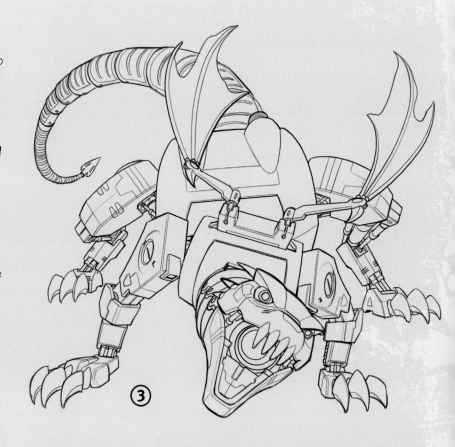

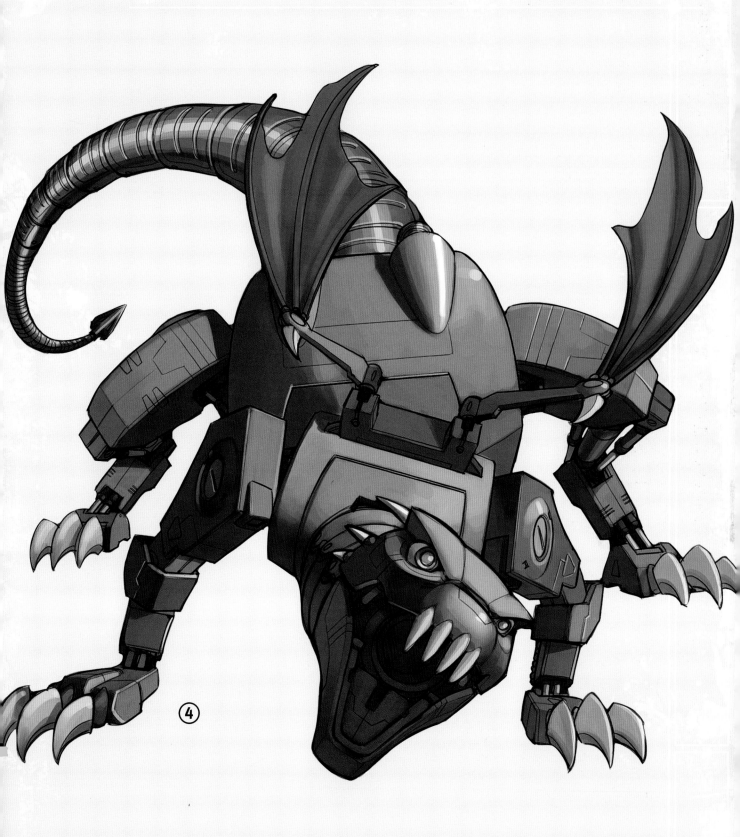

④

COMPOSING A SCENE

You can't design a scene without talking about composition. What exactly makes a good composition? That's a subject all by itself. Here are some basics to help you get started, but the concepts here are by no means the only ways to do it.

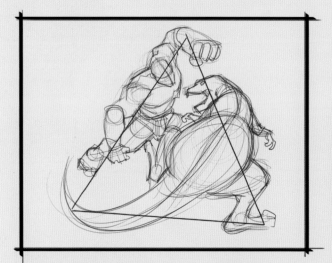

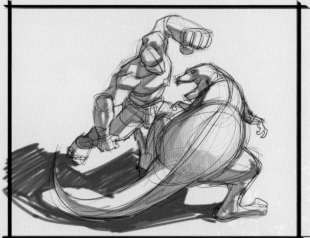

MAKE INTERESTING COMPOSITIONS

As a rule of thumb, triangular compositions will almost always be more interesting and dynamic. Arrange elements in your drawings to form rough triangles like the examples above.

USE THUMBNAILS

One of the things I do as preparation for a full-blown illustration is draw a rough, smaller version of the illustration, called a "thumbnail." The purpose of a thumbnail is to work out composition, light and/or shadow problems before doing the full-size illustration.

MOTION AND SPEED LINES

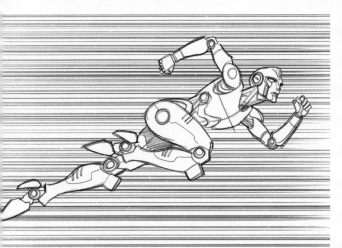

Speed lines are typically used in comic book illustrations, most heavily by Japanese comic book artists. There are a lot of artists who prefer not to use speed lines, but I think if they are used effectively, they can be a very powerful storytelling technique. Even the "King," Jack Kirby, used these techniques. I'll show you a few basic techniques on creating and using speed lines.

SIDE-TO-SIDE LINES

This is the type of effect used to represent speed from the side. The key is to vary the spaces between lines and to vary the thicknesses of the lines.

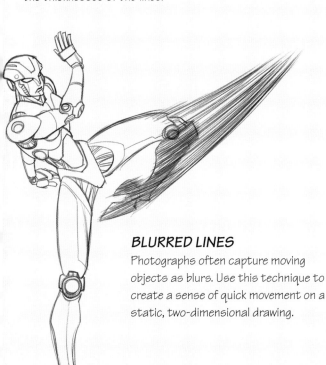

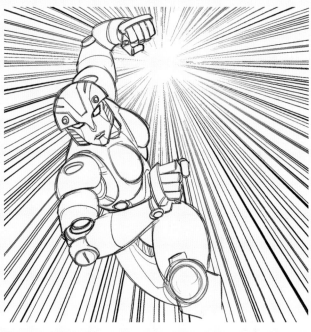

BLURRED LINES

Photographs often capture moving objects as blurs. Use this technique to create a sense of quick movement on a static, two-dimensional drawing.

FOCUS LINES

This technique is used to bring attention to a certain spot on the drawing. In this example, the focus lines are also creating the motion of the robot launching forward, and we anticipate the punch is about to be thrown.

CREATE MOOD WITH LIGHTING

Moods can be achieved through light and shadow. Lighting from different angles creates different moods. Experiment to see which lighting scheme works for which drawing.

Bottom lighting

Side lighting

DESIGNING A SCENE

A scene takes into account both the shapes of the figures and their relationship to the background. A simple background is enough to give a sense of size and depth so that the robots appear to be battling in a real place.

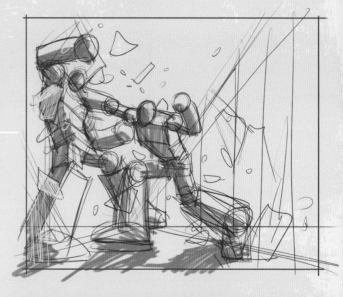

1 DRAW A THUMBNAIL OF THE SCENE
Hone your idea with a couple of thumbnail sketches to understand how you want the scene to look.

2 CREATE HORIZON LINE AND PERSPECTIVE GUIDES
Draw a series of perspective lines converging to a vanishing point in the bottom middle of the paper. The vanishing point rests on the horizon line.

3 DRAW BASIC ENVIRONMENTAL SHAPES
As you did with robots, draw the shapes of a background using the perspective lines as guides. All nonvertical lines should recede to the vanishing point.

4 DRAW BASIC ROBOT STRUCTURE AND SHAPES
Draw the basic shapes of your robots following the poses planned in the thumbnail. Start with a skeletal structure to get the poses correct, then build shapes and joints. Make sure each shape that is attached to a joint can move properly along that joint's range of motion.

5 CREATE ENVIRONMENTAL INTERACTION
Draw falling shards of building to involve the background with the action of the robot battle. Add some action "starbursts" to emphasize a point of great impact. Draw billowing dust to give the illusion of time passing.

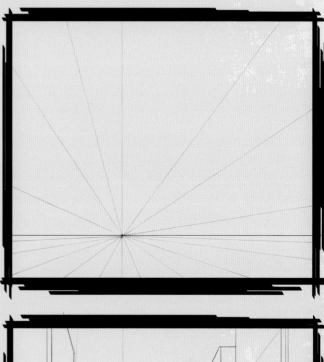

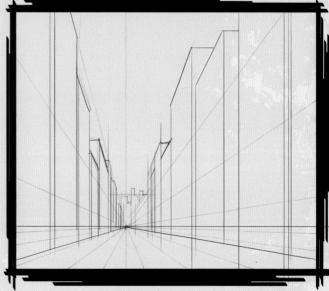

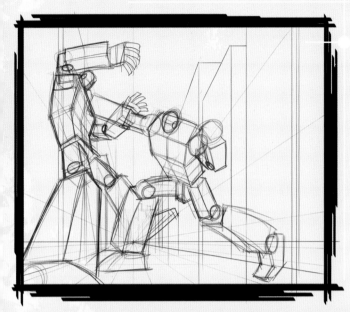

SHOWING A STORY

In order to tell a story, a scene needs to imply a sequence of events. Here, the rocks must fall before the dust clouds form. But, in order for the rocks to fall, the robot must be slammed into the building. By showing all three—the robot slamming, the rocks falling, the dust cloud forming—the scene becomes a story.

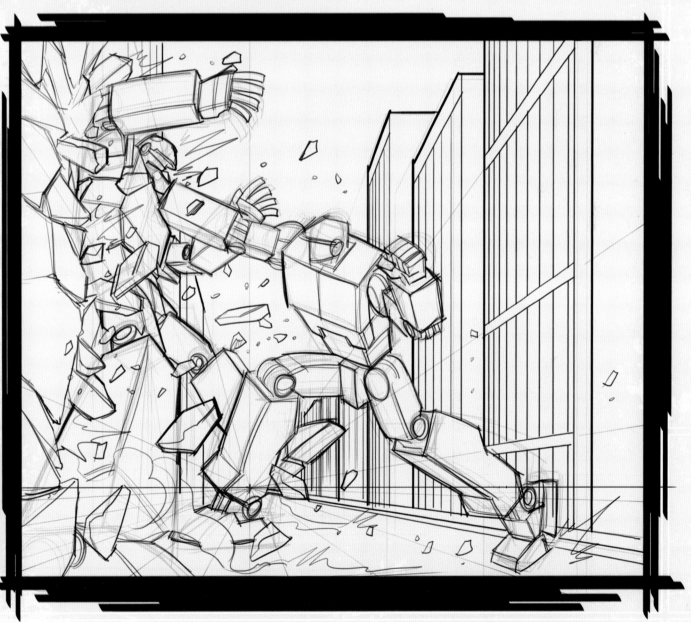

BATTLE SCENE: HUMANOID VS. HUMANOID

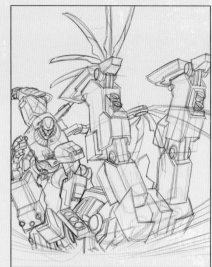

1 CREATE A THUMBNAIL

Plan the scene with a thumbnail sketch organizing who strikes whom. Understand how each robot's form is going to change when punching or falling.

2 DRAW SKELETAL STRUCTURES AND BASIC SHAPES

Draw the basic shapes of each robot in an action pose. Plan where each joint will be and how the body will bend there. Use lines to connect the joints to give an idea of the length each part needs to be to remain proportional and in perspective.

3 ADD ROUGH DETAILS

Draw the details as you would on any robot regardless of pose. Pay attention to which details should be hidden from view. Remember, the robot's limbs should be rigid with their bodies bending only at their joints.

4 FINISH DETAILS AND INK

Before coloring, ink the large shapes to set them in space. Use thick lines for the larger, more impactful shapes and thin lines for the fine details. Leave white space for coloring and to show the mass of the bodies. There should be more white space in front than farther in the back.

5 COLOR

See page 30 for methods on how to color your robots. Apply those ideas to the background, but remember to showcase the battle. The light at the point of impact here emphasizes the action. Nowhere else in the scene is the light so intense.

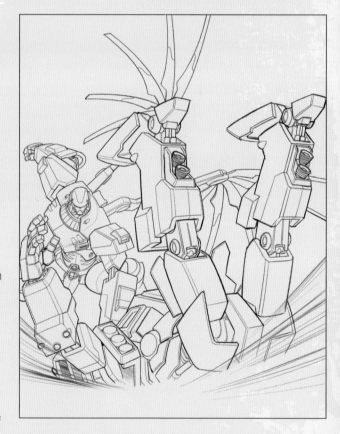

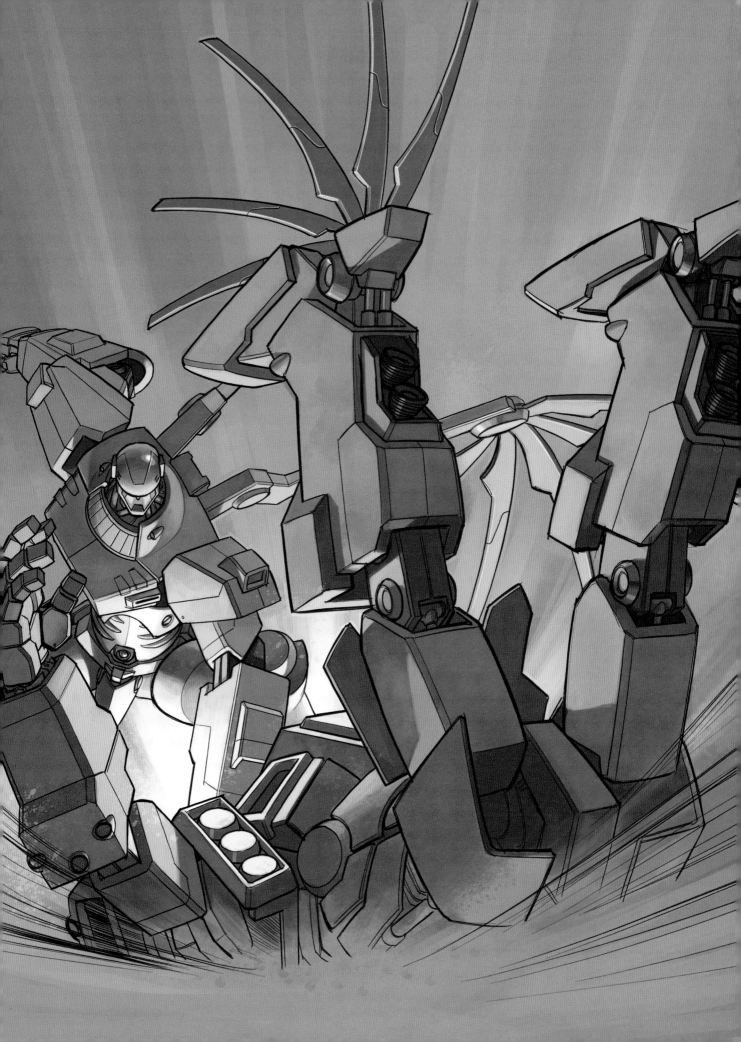

BATTLE SCENE: DRAGON VS. HUMANOID

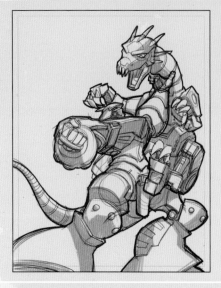 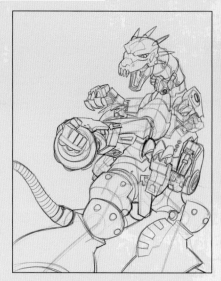

1 CREATE A THUMBNAIL
Capture the general idea of the scene in a thumbnail drawing. Map out how the robots will interact and the general locations of their bodies.

2 DRAW SKELETAL STRUCTURES AND BASIC SHAPES
Draw the basic skeletal structure of both robots. Place the joints of each so that they are proportional. Build the basic shapes around the joints along the skeletal structures. Keep the robots relatively the same size. Here, the dragon's head may be bigger, but the two chests are about equal.

3 ADD ROUGH DETAILS
Add details like the fingers, rivets and head of the humanoid, and the teeth, spikes and scalelike neck of the dragon. Work on one robot at a time to avoid confusion where the two robots overlap.

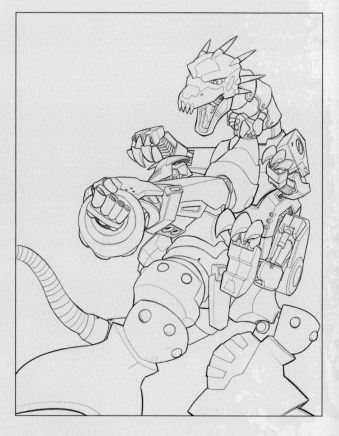

4 FINISH DETAILS AND INK
Ink the major shapes of the robots, separating their mechanical parts. Use thick lines to separate the robots from the white background space and where their bodies overlap. Use thin lines on the details. Leave white space within the bodies to show mass.

5 COLOR
See page 30 for methods on how to color your robots. Apply those ideas to the background, but remember to showcase the battle. The fire in the background here puts the scene in the context of a larger conflict.

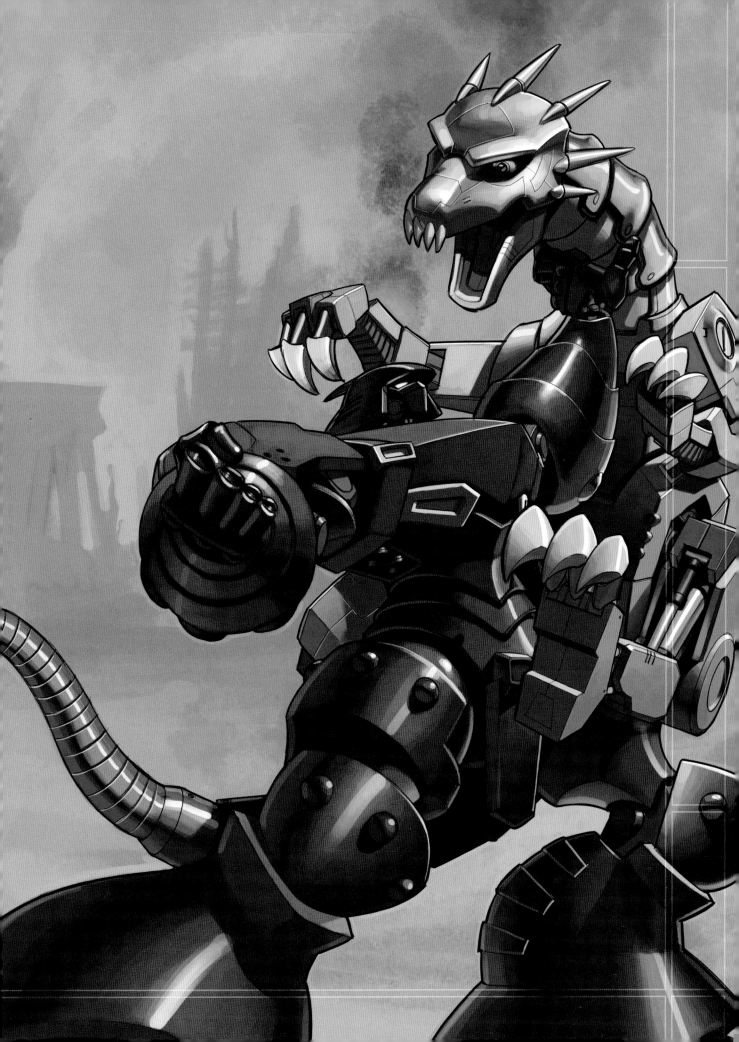

INDEX

Anatomy. *See* Robot anatomy
Ankle, 44
Ankle joint-heel assembly, 90–91
Apelike body type, 49
Arms, 38–39
Axis, 10–11

Ball-bearing joint, 47
Basic shapes, 10–11
 arms, 39
 elbows and knees, 56
 head, neck and shoulders, 35
 legs and feet, 45, 70
 torso, 37, 74
Battle pose
 dragon robot, 100–101
 humanoid robot, 62–63, 72–73
 winged robot, 82–83
Battle scene
 dragon vs. humanoid, 108–109
 humanoid vs. humanoid, 106–107
Bird's-eye view, 20
 dragon robot, 96–97
 female robot, 88–89
 humanoid robot, 58–59, 68–69
 winged robot, 78–79
Blurred lines, 103
Body type variations, 48–49

Chrome cube, 28
Chrome cylinder
 lying on its side, 29
 standing, 28
Chrome objects, multiple, 29
Chrome sphere, 29
Circle, in perspective, ellipse as, 11
Clamp hand, 43
Claw hand, 43
Color, flat, 30
Color details, 30
Coloring a robot, 30–31
Composition, 102
Cone, 11
Cube, 10
 chrome, 28
 lighting on, 26
 one-point perspective, 13
 three-point perspective, 16–17
 two-point perspective, 14
Curves, drawing, 25

Cylinder, 11
 lighting on, 26
 lopsided, 11
 one-point perspective, 13
 two-point perspective, 14
 See also Chrome cylinder
Details, repeating, 64, 86
Distance
 three-point perspective and, 17
 vanishing point and, 12
Dragon robot
 battle pose, 100–101
 battle scene, 108–109
 bird's-eye view, 96–97
 side view, 92–93
 three-quarter view, 94–95
 worm's-eye view, 98–99
Drama, foreshortening for, 22

Egg shape body type, 48
Elbow, hydraulic, 38–39
Elbow joint, 46 Ellipse, 11
 as circle in perspective, 11
 sketching, 25
Environmental interaction, 104
Extra slim body type, 48

Fantasy creatures, 51
Feet, 44–45
Female robot
 bird's-eye view, 88–89
 front view, 84–85
 three-quarter view, 86–87
 worm's-eye view, 90–91
Fingers, 40–41
Flat color, 30
Focus lines, 103
Forced perspective
 cubes in three-point perspective
 and, 16
 foreshortening as, 22–23
Foreshortening, 22–23
 bird's-eye view and, 59
Front view
 female robot, 84–85
 humanoid robot, 54–55, 64–65
 winged robot, 74–75

Geometric forms, 10–11
Geometric shapes, 90
Gun hand, 42

Hands, 40–41. *See also* Mechanical
 hand
Head, 34–35
Highlights, 30
Hip, 36
Horizon line
 one-point perspective, 12
 two-point perspective, 14
Horse robots, 50
Hot spot, 30
Human arm, 38
Human hand, 40–41
Human head, neck and shoulders, 34
Human leg, 44
Humanoid robot
 battle pose, 62–63, 72–73
 battle scene, 106–107
 bird's-eye view, 58–59, 68–69
 front view, 54–55, 64–65
 three-quarter view, 56–57, 66–67
 worm's-eye view, 60–61, 70–71
Human torso, 36

Intimidation, worm's-eye view for, 21

Joint, ball-bearing, 47
Joints, 46–47

Knee, 44
Knee joint, 46–47

Legs, 44–45
 worm's-eye view, 90
Lighting and shading, 26–27
 create mood with, 103
 on cylinder, 26
 reflective surfaces, 28–29
 on sphere, 27
 surrounding objects and, 27
Limbs, overextended, 22
Line art, robot, 30
Lines
 motion and speed, 103
 thick vs. thin, 106
Line segments, 10

Mechanical arm, 38–39
Mechanical forearm, 38
Mechanical hand, 40–41
 variations, 42–43
Mechanical head, neck and shoulders,
 34–35
Mechanical leg, 44–45
Mechanical torso, 36–37
Metric conversion chart, 4
Mood, create with lighting, 103
Motion lines, 103

Neck, 34–35
Nonhumanoid robots, 50–51

One-point perspective, 12–13
 cube in, 13
 cylinder in, 13
 robot in, 18
 scene in, 13
Organic claw hand, 43
Overextended limbs, 22

Paw, 43
Perspective
 forced, 22
 one-point, 12–13
 robots in, 18–19
 three-point, 16–17
 two-point, 14–15
Perspective grid, 12–13
Pincer, 42
Polygon, square, 10
Proportioned features body type, 48

Reflective surfaces, 28–29
Repeating details, 64, 86
Robot
 body type variations, 48–49
 coloring, 30–31
 dragon. See Dragon robot
 female. See Female robot
 in forced perspective, 23
 humanoid. See Humanoid robot
 nonhumanoid, 50–51
 in perspective, 18–19
 winged. See Winged robot
Robot anatomy, 33–51
 arms, 38–39
 hands and fingers, 40–41

hand variations, 42–43
head, neck and shoulders, 34–35
joints, 46–47
legs and feet, 44–45
torso, 36–37

Scene
 composing, 102
 designing, 104
 one-point perspective, 13
 sequence of events in, 105
 three-point perspective, 17
 two-point perspective, 15
Shading, lighting and. See Lighting and
 shading
Shadow, defining, 30
Shapes, basic, 10–11. See also Basic
 shapes
Shoulder joint, 34, 47
Shoulders, 34–35
Side-to-side lines, 103
Size, sense of, 20
Skeletal structure
 battle pose, 62, 72, 82
 bird's-eye view, 58, 68, 78, 88
 front view, 54, 64, 74, 84
 three-quarter view, 56, 66, 76, 86
 worm's-eye view, 60, 70, 80, 90
Sketching techniques
 correct vision, 24
 curves, 25
 distorted vision, 24
 ellipses, 25
 long vs. short strokes, 25
Speed lines, 103
Sphere, 10
 chrome, 29
 lighting on, 27
Spider robots, 50
Square polygon, 10
Stance, imposing, 18
Starbursts, action, 104
Story, showing, 105
Strokes, long vs. short, 25

Tank body type, 49
Thigh, 36
360° joint, 47
Three-point perspective, 16–17
 robot in, 19
 scene in, 17

Three-quarter view
 dragon robot, 94–95
 female robot, 86–87
 humanoid robot, 56–57, 66–67
 winged robot, 76–77
Thumbnail, of scene, 102, 104
Tiger robots, 51
Torso, 36–37
Tri-claw, 42
Two-point perspective, 14–15
 cube in, 14
 cylinder in, 14
 robot in, 18
 scene in, 15

Vanishing point
 distance and, 12
 one-point perspective, 12–13
 three-point perspective, 16–17
 two-point perspective, 14–15
Vision
 correct, 24
 distorted, 24

Walker body type, 49
Winged robot
 battle pose, 82–83
 bird's-eye view, 78–79
 front view, 74–75
 three-quarter view, 76–77
 worm's-eye view, 80–81
Worm's-eye view, 21
 dragon robot in, 98–99
 female robot in, 90–91
 humanoid robot in, 60–61, 70–71
 legs in, 90
 winged robot in, 80–81

IF YOU'RE GOING TO DRAW, DRAW WITH IMPACT!

Unleash hell with top gaming artist Jim Pavelec (*Dungeons & Dragons, Magic: The Gathering* and many others). Progressing from basic to the more developed, you'll find everything you need to start drawing a plethora of gruesome creatures. *Hell Beasts* features over 25 step-by-step demonstrations that examine skeletal structure, musculature and organic features of monsters, allowing you to achieve realistic results. This book will teach you to draw the stuff nightmares are made of!

ISBN-13: 978-1-58180-926-8
ISBN-10: 1-58180-926-3
Paperback, 128 pages, #Z0569

It can take thousands of drawings to develop a sense of perspective. With *Vanishing Point*, you'll learn how to create successful perspective drawings fast the first time around by understanding where to place their vanishing points. I mean c'mon, no other book on the market features a detailed section devoted to five-point curvilinear perspective! Ideal for comic and fantasy artists, *Vanishing Point* will show you how to draw the scenes that before had only existed in your head.

ISBN-13: 978-1-58180-954-1
ISBN-10: 1-58180-954-9
Paperback, 128 pages, #Z0664

Put yourself on the fast track to comic-stardom! *Incredible Comics With Tom Nguyen* not only shows you how to draw hot character types, including hunky heroes and sexy babes, but also reveals the secrets pros use for paneling and storytelling. This book gives you a thrilling crash course in figures, clothing, background and perspective then shows you how to construct complete comic book pages using sample scripts from a real DC comics writer. No aspiring comic artist can afford to miss what this truly incredible (not to mention kick-ass) book offers!

ISBN-13: 978-1-58180-946-6
ISBN-10: 1-58180-946-8
Paperback, 128 pages, #Z0662

THESE AND OTHER MIND-BLOWING IMPACT TITLES ARE AVAILABLE AT YOUR LOCAL BOOKSTORE OR FROM ONLINE SUPPLIERS. ALSO VISIT OUR WEBSITE AT WWW.IMPACT-BOOKS.COM.